DOWN EAST
MAINE

forgotten TALES *of*

DOWN EAST
MAINE

JIM HARNEDY

illustrations by
Sarah Haynes

THE
History
PRESS

Published by The History Press
Charleston, SC
www.historypress.com

First published 2019

Manufactured in the United States

ISBN 9781467139861

Library of Congress Control Number: 2019932637

CONTENTS

Contents

1

WHO REALLY DISCOVERED AMERICA?

THE FIRST PEOPLE HERE WERE THE NATIVE AMERICANS

When most of us were in elementary school, we were introduced to the history of how America was inhabited by Native American tribes prior to exploration by Europeans. We all heard that Christopher Columbus had discovered America in 1492 and that he was followed by Spanish explorers, including Hernán Cortés, Hernando de Soto and Juan Ponce de León. We were also told that both the English and French wanted to engage in this new wave of exploration but decided to keep their travels to the north of Florida because of Spain's powerful naval might.

The motivation for exploration was driven by a search for riches and a northwest passage to Asia. John Cabot, an Englishman, in his search for the northwest passage, found Newfoundland instead. Here in Maine, elementary school students, who had great teachers, learned that the native peoples who inhabited Maine were members of the Micmac, Mailiseet, Penobscot and Passamaquoddy tribes. These peoples spoke an Algonquian language and collectively formed the Wabanaki Confederacy and were called the "People of the Dawn."

What has almost become footnotes to history is the fact that the first two colonies settled in New England, more than a decade prior to the Plymouth Colony, were here in Maine. In 1604, the French explorers Pierre Dugua de

Mons and Samuel de Champlain established the ill-fated St. Croix Colony just off of Calais. In 1607, the English established the Popham Colony in Phippsburg, at the mouth of the Kennebec River. Unfortunately, Maine winters proved to be too much for these colonists, and they all returned to England within a year.

THE IRISH MAY HAVE BEEN HERE FIRST

Digging deeper into legends of who was here first, some research points to stones discovered across northern New England. The stones appear to be Ogam inscriptions, believed to have been written by Celts one thousand years before the birth of Christ. How they could have gotten here is a mystery.

There is an amazing legend about St. Brendan the Navigator, an Irish monk who lived around AD 563. His odyssey is extraordinary. It is alleged that he was passionate about finding a mystical Isle of Saints. Brendan believed the existence of this spiritual place was located west of his monastery at Baalynevioorach, in County Cork. It is from there that Brendan, with seventeen fellow monks, embarked on a seven-year seafaring search for the Isle of Saints in a boat made from greased tanned hides. It is possible that their voyage culminated in the New World, possibly in Maine. The story of Brendan's adventure was believed in early times, but over the years, it became questioned as being a myth or a parable created by a zealot monk to promote Christian spirituality.

In 1976, Tim Severin, a British explorer, historian and writer, decided to challenge the authenticity of St. Brendan the Navigator's legend by duplicating the total alleged process. First, he built the boat, using all of the same material and tools available to Brendan. Then, Severin, along with seventeen fellow explorers, set out from Ireland on their voyage, which successfully made it to North America and clearly demonstrated that the legend of Brendan's voyage was feasible.

The Irish claim to have discovered America, and they have some other interesting relics to support their case. Stone beehives of various sizes have been found all across New England. Initially, these were thought to be root cellars of the early colonists, but Byron Dix, an archaeologist and astronomer, has determined that these stoneworks are astronomically aligned chambers and resemble similar facilities built by Irish monks.

Just off Monhegan Island is Manana Island, a small adjacent island where a rock was found that appears to have been chiseled with inscriptions thought to be in old Celtic language. Current research continues to show proof that these ancient legends have some basis in fact.

The Vikings Have a Claim to Arriving First

Nearly five hundred years before Columbus sailed on his New World voyage, a group of Scandinavian seafaring warriors—known as Norsemen and/or Vikings—not only plundered Britain but also made voyages to North America and established a colony on Newfoundland.

Several specific findings place the Vikings in Down East, Maine. The prehistoric Goddard Site is located on the Blue Hill Peninsula, in the town of Brooklin. Digs have been conducted there for years by archaeologists, who found a large number of artifacts including pottery remnants and a series of post molds that indicate that a longhouse may have been present there. On August 18, 1956, an amateur archaeologist found a silver coin at the site, which certainly could not be linked to Native Americans. The coin was given the name the "Maine penny." It was initially incorrectly identified, but in August 1978, the coin was correctly identified as being a Norse coin dating to the reign of Olaf Kyre, "Olaf the Peaceful" (1067–1093). The following year, the site was listed in the National Register of Historic Places.

In January 2014, Susan Esposito wrote a feature article, "Possible Norse Settlements Downeast Explored," in the Eastport newspaper the *Quoddy Tides*. Her article noted that many older folks in Washington County proclaimed in their oral history their belief that a Norse settlement existed in the region in the distant past.

Professor emeritus Harold Borns Jr., who spent thirty years doing fieldwork studying the ancient history of eastern coastal Maine for the University of Maine, confirmed that many elders of the area believed that the Vikings had explored and settled in the region.

Two Icelandic tales written around 1350 describe the Vikings' discoveries and their brief settlement in a place they called Vineland. Scholars through the years have come to believe that Vineland was located in the northeastern United States.

Scholars have also found through studies that Leif Erikson's brother Torvald, together with other Norsemen, spent several years in Vineland.

Navigational data of the period that has been found points out that the area could have placed them in the Bay of Fundy or Passamaquoddy Bay. Several places, including Norse Pond, located in Trescott between Cutler and Lubec, are major contenders for the place where they settled.

The verdict is still out on whether our earliest history needs a rewrite. We all love a mystery, so stay tuned for ongoing research findings.

2

A MONUMENTAL MYTH

Bucksport, Site of Maine's Earliest Inhabitants

Thousands of years ago, in the area now known as Bucksport, an advanced indigenous people called the Red Paint People lived. These people were known for their fishing and for burying their deceased with tools, weapons and red paint. These people were followed by Wabanaki Native Americans who lived along the Penobscot River.

The Colonization Era

In 1762, the Massachusetts General Court granted a tract of land that included Bucksport to Deacon David Marsh and 351 other residents of Haverhill. Among these grantees was John Buck. That year, Buck and other grantees journeyed up to the Penobscot area on their sloop *Sally* to survey the six plantations in their grant. These plantations became the incorporated towns of Bucksport, Castine, Orland, Sedgewick, Blue Hill and Surry. After completing the surveying task, they returned to Haverhill. In June 1763, John Buck returned to his newly acquired grant and built a home, store and sawmill. By 1775, twenty families had joined the Bucks in their plantation.

Jonathan Buck married Lydia Morse on October 14, 1742. He and Lydia had seven children. During the Revolutionary War, Jonathan fought in the ill-fated naval battle at Castine, which turned out to be the American navy's worst defeat until Pearl Harbor. Following the British destruction of the American forces on April 14, 1779, they proceeded to burn the settlements of Jonathan Buck and his neighbors. The signing of the peace treaty of 1783 led to the resettlement of the plantation. The resettled community was named Buckstown Plantation in honor of its founder. It was officially incorporated as Buckstown on June 27, 1792, and in 1817 it was renamed Bucksport.

THE MYTHS

A number of myths have arisen over the years relating to the appearance of a leg on Colonel Jonathan Buck's gravestone. The first known record of it in print is an article in the March 22, 1899 issue of the *Haverhill Gazette*. Perhaps because it was the first to report the phenomenon, its story of the "The Buck Legend" has become the classic version. The

Gazette states that Jonathan Buck was a Puritan. The sect's religious beliefs vehemently opposed any form of witchcraft. When a woman was accused of witchcraft, she was sentenced to be executed by hanging. The woman accused of witchcraft in the Jonathan Buck case is alleged to have spoken her last words to Buck, saying that he would soon die and that on the memorial stone erected for him, an imprint of her feet would appear to acknowledge that Buck had murdered a woman.

Other versions of this myth have popped up over the years. In the September 1902 edition of the *New England Magazine*, an article titled "The Witch's Curse: A Legend of an Old Maine Town" by J.O. Whittemore stated that Jonathan Buck was the judge who sentenced the woman to be hanged. Like in the earlier version, the witch allegedly prophesied early death and the appearance of her foot on his gravestone.

In 1913, the author Morrill Heath incorporated this story in a book of short stories. His version alleged that the witch was Jonathan Buck's mistress and that she was pregnant again by him at the time of her execution. In this version, her death was to occur by being tied to the door of her house and then setting her on fire. While she was burning, Buck's illegitimate son grabbed her leg and hit Buck with it, permanently crippling him. The boy held this leg as a relic, and when his father died ten years later, he placed it in the coffin. The story goes on to relate that when this leg touched the dead Buck, it caused him to emerge from his coffin, go down to his monument and draw an image of the leg on it with his own blood. He then returned to his coffin and asked the son to close the lid.

The myth surrounding Jonathan Buck's gravestone monument continues to get attention. I recently heard the story told on a local TV channel. Skeptics claim there is no curse associated with the monument and that the marking is likely the result of a natural flaw in the stone, including the possibility of a vein of iron that darkened through contact with oxygen at the time the stone was cut.

I suspect the legend will continue to live well into the future.

3

THE SERPENT OF POCOMOONSHINE LAKE

Pocomoonshine Lake has often been described as a tranquil, serene and beautiful spot in Baileyville, Maine, and one of Washington County's true gems. Beneath the lake's quiet pristine beauty, a monster has been lurking for eons. Most folks who live in the area have heard of the legend, and some who have allegedly seen it or its trail are not about to divulge their experience, for fear of ridicule.

Like the Loch Ness monster of the Scottish Highlands, the Pocomoonshine creature has been reported for thousands of years. State archaeologist Mark Hedden, at a petroglyph exhibit at the University of Maine at Machias, described the characters that the Passamaquoddy people had engraved into rocks along the Machias River some 3,000 to 1,500 years ago depicting a shaman and his brother spirit, moose, deer and a huge water serpent.

The *Machias Union*, published by Messrs. Drisko and Parlin, ran an article in its March 21, 1882 issue titled "Chain Lake Snake." The article was actually a letter from Sewell S. Quimby of Wesley. The letter's purpose was to refute the existence of any monster.

The content of Mr. Sewell's letter to the editor told how he heard a man describing with great earnestness that he had seen a man who saw the great snake and that they were going to lease the ground around Chain Lakes for hunting. The owners were already having great chains made, huge traps constructed and harpoons, lances, spears, gaffs and barbs in

readiness when spring opened. They were going to capture if possible the monster of the mighty deep, now landlocked in the small freshwater ponds of the Machias Chain Lakes.

He stated that a short time later he heard another person saying with the same level of conviction that he, too, had seen a man who saw the man who said he saw the great snake. Two persons, Hall and Libby, were on the shore of Chain Lake, and they said they heard a noise and saw what they thought to be a man in a skiff but soon became convinced that what they saw was a serpent. They went on to say that its smallest part was as large as a pork barrel. The last they saw, this creature had left the water and passed a distant point of land covered with granite boulders.

Quimby's letter goes on to refute Hall and Libby by stating that he was also at the lake that day, having gone there to pick up some boards and other supplies for a camp, including a barrel stove that he placed on the bow of his skiff. He then rowed his skiff down the lake and to the outlet, where there are no granite boulders. He concluded by saying that if Hall saw granite boulders where there was none, well, he likely saw a monster where there was none.

In more contemporary times, Pocomoonshine Lake has become the destination for folks "from away" looking to escape their busy lifestyles and perhaps do some great bass fishing. The fishing has consistently

been reported as excellent, but along with that is the high number of snakes seen. Perhaps if one of the vacationers could capture a photo on their smartphone, Pocomoonshine Lake's serpent would become even more famous than the Loch Ness monster and put Bailyville, Maine, on everyone's bucket list.

4
A FRENCH CONNECTION LEGEND

Maine's Famous Feline

The Maine Coon cat is one of the largest domestic cat breeds. It is a very old breed and native to Maine. The Maine Coon is known for its hunting skills. The cat's large size and sociable nature has earned it the nickname the "gentle giant."

The origin of the breed remains cloudy. Some believe it originated as a mix of short-haired domestic cats bred with long-haired European cats brought here from Europe as ship cats. Another theory proposes that they arrived here in the 1300s with the Vikings. We do know that these wonderful Maine felines have lived and flourished here.

In the late 1860s, Maine farmers told stories about their wonderful cats and organized the "Maine State Champion Coon Contest" at the annual Skowhegan Fair. In the late 1800s, cat fanciers showed Maine Coon cats at major shows in Boston and New York. In the early twentieth century, the breed's popularity began to decline on the show circuit due to the introduction of other long-haired breeds, like the Persian. As time went on, it appeared that the Maine Coon was becoming extinct. Members of this iconic Maine feline heritage could only be found during the period of the 1920s through the 1940s as Maine barn cats. In the summer of 1940, I acquired a Maine Coon kitten from a litter born in a barn on Deer Island, Moosehead Lake. He became a family member and was a wonderful cat.

The breed started making a comeback in the 1950s and today is one of the most popular breeds. The Maine legislature in 1985 recognized the Maine Coon cat as the state's official cat.

HOW THE FRENCH REVOLUTION TOUCHED MAINE

This is a story of how the French royal family during the height of the French Revolution almost escaped the guillotine and made it to America. Instead of Marie Antoinette making it out of France, her royal cats may have been the lucky ones that started a new life on Maine's mid-coast.

During the French Revolution period, a shipping company in Wiscasset, Maine, owned by Colonel James Swan had contracts with firms in Paris,

and his ships sailed between Wiscasset and France on a regular basis. One of his captains was Stephen Clough, who sailed the *Sally*. During the summer of 1792, Captain Clough left Wiscasset for the destination of the port of Le Havre, France.

At the time of the *Sally*'s arrival in France, French revolutionaries had arrested Marie Antoinette and King Louis XVI, ransacked their castle and placed them in Temple Prison. A group of royal sympathizers wanted to develop an escape plan to get the royal couple out of prison and off to America. They were able to plot with Captain Clough to hopefully get them on the *Sally* and then to Wiscasset. While the royal couple was in prison, their palace finery was being sold on the street. The sympathizers thought that Marie Antoinette and Louis XVI would feel more at home in the New World with some of their old possessions, so Captain Clough and some others bought up the goods and loaded them on the *Sally*. It is believed that Marie Antoinette's royal cats were among these goods.

Unfortunately for the royal family, the plan of their escape was not pulled off, so in the fall of 1793, Captain Clough set sail for Wiscasset. On his arrival home, his wife was disappointed, as she thought from a letter that she had received from her husband that she would be hosting the royal couple.

The goods that Captain Clough brought from France were divided between the captain and Colonel Swan. The Clough home was soon to become known as the Marie Antoinette House. A little less than a year after Captain Clough returned home, his wife gave birth to a daughter; she was given the middle name Antoinette. The Clough house was originally built on Squam Island in 1744 but moved over ice during the winter of 1838 to its present location in Edgecomb.

You be the judge whether the Maine Coon cat is of royal lineage.

5
PAUL REVERE THE ENTREPRENEUR

The Patriot

The heroic "Midnight Ride" by Paul Revere to warn his fellow Americans that the British were coming was made part of our culture by Henry Wadsworth Longfellow's poem, which is learned by every kid in grammar school. Revere's patriotic feat on that night foretold of the first encounter of the Revolutionary War at Lexington and Concord.

A Legacy Nearly Lost

Paul Revere's involvement in the Revolutionary War didn't end with his famous ride. He continued to serve as an officer in the Massachusetts militia. The Massachusetts legislature was aware that the British had seized the village of Castine and was starting to equip it as a fortress from which to launch attacks. The legislature appropriated large sums of money to fund the Massachusetts navy and militia to counter the British offensive plans. Joining with ships from the Continental navy, the large American flotilla under the command of Commodore Dudley Saltonstall sailed down east into Penobscot Bay. On July 25, 1779, the American assault started. For some unknown reason, Saltsonstall refused to attack the British armed fleet

until General Solomon Lovell's militia had captured the British fort on the mainland. The engagement dragged on for several weeks until a British relief fleet arrived and went to work destroying the American fleet. The remaining American ships with the militia included Lieutenant Colonel Paul Revere and his artillery company. To avoid capture, they retreated up the Penobscot River. The Penobscot Expedition was a total failure, and the naval defeat was the worst American navy loss until Pearl Harbor.

As is often the case in a disaster, a scapegoat was needed. Paul Revere became the target, as he was thought to be an arrogant person by both his troops and fellow officers. Some just wanted to settle old scores, while others accused him of insubordination of orders, neglect of duty and cowardice.

Shortly after his return to Boston, he heard about an investigation going on relative to his action during the Penobscot Expedition. The investigating body did not rule on his conduct. This left his integrity and patriotism up in the air.

Wanting his name cleared, Revere requested a formal court-martial, but it was not until 1782 that a court-martial met, heard his case and acquitted him of the charges filed against him. The court decided that the militia was in such disarray during its retreat that regular orders could not be followed.

The outcome was that Paul Revere's reputation was restored.

The Revere Enterprise

Paul Revere's father, Apollos De Revoir, was a Boston silversmith who operated the Silver Shop until his death in 1754. Paul worked as an

apprentice under his father and took over the management of the business in 1761. The shop made a great many items, including flatware, cups, tankards, trays, bowls, coffee and teapots, sugar tongs, snuffboxes and even surgical instruments. Paul added lucrative engraving to his shop so he could place monograms or crests on customers' items.

From his engraving addition he expanded into the printing business while also opening a hardware operation.

Paul's next major venture was to launch a foundry in 1792. He was soon known for making fine bells. Over the years, he and his son turned out nearly four thousand bells of various sizes as well as weathervanes and other forged products. His brand was considered to be the best in America.

His sales of bells to churches throughout Maine is amazing when one looks at the distance he had to cover. His bells are found at First Parish Church in Kennebunk. The Second Congregational Church of Wiscasset placed a Revere bell in its belfry and a weathervane on the top of its steeple. Neighboring Head Tide Church in Alna also purchased a Revere bell. Maine's oldest Catholic church, St. Patrick's in Newcastle, as well as the oldest Episcopal church, Christ Episcopal in Gardiner, have Revere bells. Way Down East in Machias, Captain Stephen Longfellow, a parishioner of the Centre Street Congregational Church, traveled to Revere's foundry in Boston to purchase a bell for the church. He chose a bell that was not new but had in his opinion a clear and mellow sound that would be perfect for his church.

By any measure, Paul Revere had an illustrious life as a patriot and as an entrepreneur with accomplishments in both Massachusetts and Maine.

6

MOLLY OCKETT, HEALER AND PROPHET

The Early Years

Molly Ockett was born around 1740 into the Pigwacket Band of Maine Native Americans. Molly's peoples' ancestral home was along the banks of the Sacco River. They spoke the Algonquian language and with other bands and tribes were collectively members of the Wabanaki Confederation. Her parents had become Christians like many other Wabanaki people via French Jesuit missionaries. These converts did integrate their traditional spiritualism with their Catholic faith.

Molly was baptized Marie Agathe. To some local English-speaking people, she became Molly Agatha. To her own people, her Christian name sounded like "Molly Ockett." The 1740s in New England was a turbulent period, due to constant battles between the English and French. In 1744, the Pigwacket Band cast its lot with the English, thinking this would provide them with the best chance to survive. The Pigwacket women and children were moved by their English protectors to Massachusetts, but the men were allowed to stay in Maine. During her exile to Massachusetts, Molly spent eight months living in the home of a Boston judge. This proved to be an excellent learning experience, as she observed how the English lived. This would benefit her as an adult.

After returning to family life in Maine, she continued to follow in the ancient traditions of her people, migrating to the ocean in the summer

months and returning inland during the fall and winter. When war erupted again, her family decided to seek sanctuary at the Canadian mission of Odanak, located along the St. Lawrence River. An English raid on the mission resulted in the killing of her entire family. Molly and a few others were the only survivors. After this horrific event, Molly and the other survivors returned to an area near present-day Fryeburg.

FOLLOWING TRADITION

Molly knew that she was a smart, strong Pigwacket woman who was destined to follow her people's ancestral traditions. She was described as a pretty, warm and gentle person possessing a large frame. She was known to be a fine hunter. If she made a kill of a large deer or moose near a colonial settlement, she would ask one of the settlers to help drag her kill out of the woods. She would then share the meat with her helper. Molly lived according to her beliefs and values, but that did not stop her from developing close relationships with some of the white settlers. As she wandered through the area, Molly collected the herbal medicines that she had learned about. Molly administered her remedies to the settlers whenever the need arose, as she was the only doctor available. She was referred to as "Androscoggin Valley's Florence Nightingale." Molly never accepted more than one penny for her healing services.

The Hamlin family of Paris Hill told the story of how Molly saved the life of the infant Hannibal Hamlin and predicted that he would become a very famous man. Her prediction came true, as Hannibal had a successful career as a publisher, lawyer and politician, serving as a U.S. representative, U.S. senator and Abraham Lincoln's first vice president.

Molly often visited springs in Poland and believed they provided medicinal powers. She was a friend of Wentworth Ricker, who owned the local inn. He and his family must have put some stock in Molly's claim about the springs, as their descendants established the famous Poland Spring House and promoted the spring water's healing qualities.

Molly's legacy is that she lived her life as a courageous Native American woman. She died in 1816 in Andover, Maine, and was buried in an unmarked grave there. Some years after her death, a headstone was placed on her grave that reads: "MOLLOCKET Baptized Mary Agatha, died in the Christian Faith, August 2, A.D. 1816. The last of the Pequakets."

THE HAUNTED
SEGUIN ISLAND LIGHT

THE HISTORIC LIGHTHOUSE

On a barren bank of rocks at the mouth of the Kennebec River lies Seguin Island. The island itself is located just south of Georgetown Island and Phippsburg, which was the site of the short-lived English Popham Colony. Seguin Island is a part of Georgetown in Sagadahoc County.

The name "Seguin" has several meanings. One claim is that it comes from the Algonquian word *sequnau*, meaning "alone out to sea." In the Abenaki language, it means "a hump." The best that can be said is that uncertainty exists about the island's name.

In 1795, the Seguin Island Light Station was commissioned by President George Washington. It is Maine's tallest and second-oldest lighthouse. It is still fully functional and is now maintained by the Friends of Seguin Island Light Station. This group was granted a lifetime lease in 1986 and ownership of the island from the federal government in 1995. Seguin Island Lighthouse is in the National Register of Historic Places.

During the light's first 150 years of service, it was operated by U.S. Lighthouse Service. Operations then were turned over to the U.S. Coast Guard, which maintained its operation until 1986.

The island has a reputation for being blanketed by fog more than 30 percent of the time. It is equipped with one of the loudest foghorns to warn mariners of danger in the area. Seguin Island Light has also earned the

reputation of being Maine's most haunted lighthouse and perhaps the most haunted light in New England.

THE ISLAND'S FIRST LIGHTKEEPER

Major John Polereczky became the first lightkeeper for Seguin Island Light. He was a count of Hungarian nobility who had been born in France and had fought with Marquis de Lafayette's French army forces in the American Revolutionary War.

After the war, Polereczky settled in Dresden, Maine. He soon became active in community affairs and was appointed to the position of town clerk. After spending twenty-five years as town clerk, he applied for the position of keeper of Seguin Island Light. He was accepted for this position and started his duty on the island in 1798. Polereczky felt that the remoteness of this outpost should pay a much higher salary than the meager one he was receiving. He constantly asked for an increase, but his requests fell on deaf ears.

For a brief period, his brother-in-law Christopher Pushard served as his assistant. Polereczky initially brought his wife to the island, and their first child, Jane, was born there. After her birth, his wife and child left the island. Relations between the two brothers-in-law became strained, and Pushard left the island.

John Polereczky died on the island after serving eight years as the light's first keeper. He was penniless at the time of his death. Over the years, reports of his ghost have been reported by many who claim that they have encountered him climbing the staircase to the tower. Those who have had these sightings have named him the "Old Captain."

DAYS OF THE U.S. LIGHTHOUSE SERVICE

A number of keepers were to follow John Polereczky. Faced with life on a barren rock that was often in dense fog, depression can result. During the mid-1800s, Polereczky's wife had become very depressed. In an attempt to lift his wife's spirits and provide her with a way to enjoy a new hobby, he ordered a piano to be shipped out to the island. His wife was excited at the

thought of learning something new and at the same time helping to relieve her depression.

The piano came with a songbook. The lightkeeper's wife selected a song from the book and took up a formal discipline of learning how to play the tune. She practiced the same tune for hours on end. Every day, the woman would play the same tune over and over. After months of being subjected to hearing the same song, the lighthouse keeper went mad. He went to his tool chest, found his axe and went to work chopping the piano into small pieces. Upon finishing with the piano, he turned his madness on his wife and bludgeoned her to death. When he realized what he had done in his rage of madness, he took his own life.

Visitors who come to see the light often report hearing the haunting sound of a piano playing softly in the lighthouse, but when they go and check, they find the lighthouse empty. It is believed that the ghost of the wife of the lighthouse keeper refuses to leave the place of her murder. Some even claim to have seen her playing a phantom piano. Others have claimed to see a ghost figure of the lighthouse keeper trekking around the island with an axe in hand.

More Ghost Tales

The "Old Captain" enjoys getting the attention of folks working at the light. Shortly after the light had been automated in 1985, a crew was sent to the island to remove all of the furniture from the lighthouse. The crew prepared all of the items for shipment and were to load them on a ship the following day. They were to stay that night on the island. In the middle of the night, the supervisor was awakened by the shaking of his bed. The Old Captain, dressed in oilskins, appeared to him and told him not to move any of the furniture from his home. The supervisor thought that he must have been in a deep dream and did not intend to oblige the Old Captain's request. The furniture move went ahead as planned. The items were successfully loaded onto a boat, but when the boat was being lowered into the water, the cable lowering the boat mysteriously snapped. Everything crashed onto the rocks and broke into a million pieces.

The Old Captain has made his appearance known many more times over the years to volunteer caretakers who annually help to prepare the lighthouse for summer visitors. Among the many strange paranormal events

these volunteers have reported include items being moved around inside the house, tools vanishing and items being flung from a shelf to the floor, as well as doors being opened and closed. Some of the volunteers have reported what sounded like coughing coming from an unseen source, which they attribute to the Old Captain.

A completely different paranormal tale involves the death of a young girl on Seguin Island. According to the tale, her parents buried her body somewhere close to the house or the large foghorn. She had an illness, so she was sometimes observed to be coughing. At other times, she was seen smiling and skipping about the garden. Her various escapades have been witnessed by both former lighthouse keepers and summer tourists to the island.

Perhaps the Old Captain performed one of Sequin Island's most notorious paranormal events. A U.S. Coast Guard warrant officer went out to the island to pack up some of the last bits of furniture that remained. Being late in the day, the officer decided to remain on the island for the night and return to the mainland the following day. That night, a man dressed in an oilskin awakened him by shaking his head violently. Before disappearing, the ghost said, "Don't take my furniture. Please leave my home alone."

How Brave Are You?

Transportation to Sequin Island can be arranged through cruise boat companies in both Boothbay Harbor and Bath. If you have your own boat, you are welcome to go out to the island for a visit. If you are a brave soul, you can make arrangements to spend a night checking out the most haunted lighthouse in Maine.

THE "PORK AND BEANS WAR"

AKA THE AROOSTOOK WAR

The "Pork and Beans War" is more traditionally called the Aroostook War. It is better described as an international boundary dispute between the British colony of New Brunswick and the United States (and Maine) from 1838 to 1842. The potential conflict was resolved by a diplomatic compromise negotiated in Washington, D.C., between Daniel Webster for the United States and Lord Alexander Ashburton for Britain.

THE CAUSE OF THE DISPUTE

The Treaty of Paris, signed between the American colonies and Great Britain in 1783 to end the Revolutionary War, provided a rather poorly defined description of the border between the future state of Maine and the British colony of New Brunswick. The border issue didn't become important until the quest for timber brought lumberjacks from both sides into conflict.

American and British diplomats who signed the Treaty of Ghent, which ended the War of 1812, appointed a commission to resolve the various boundary issues that had emerged due to the fact that large sections of Washington, Hancock and parts of Penobscot Counties had been captured by the British during the war and were being returned to the United States

as part of the treaty agreement. The coastal areas, including the islands, were the major scope of the commission's resolution. The northern region of present-day Maine that borders New Brunswick along the St. John and Aroostook River Valleys was left unsettled.

The French-speaking settlers of this northern area, who were descendants of the early Acadian colonists, considered themselves to constitute an unofficial separate nation, owing allegiance to neither America nor Britain. Thus, this area was a sort of a "no-man's area" when it came to real estate ownership.

Border status arose as a significant issue when Maine became a state in 1820. At the time of separation of Maine from Massachusetts, half of the public lands in Maine were retained by Massachusetts. The British were worried that the new state was claiming that its border reached up to the St. Lawrence and would jeopardize their fast travel route between Quebec City and Halifax, Nova Scotia.

Over time, some Americans moved into the St. John River Valley to take advantage of the rich woodlands available for harvesting. Disputes between groups broke out over who was to control the great timber resources. Due to the remoteness from governmental authorities, resolutions did not happen and property rights remained unaddressed.

A Strange Moniker

"Pork and Beans" doesn't bring to mind a culinary delight. But for the rugged lumberjacks of Maine and their New Brunswick brothers in trade—as well as for the British troops who served in this remote wilderness station—a hearty diet of pork and beans was appreciated. Thus, the commonality of the grub seemed an apt name for the dispute.

Gearing Up and Standing Down

The Mainers were pretty keyed up about going to war against the "Red Coats." They even came up with a ditty to express their feelings: "We'll feed them well with ball and shot. We'll cut those red coats down, before we yield them an inch."

The Maine state government mobilized some "possies" to defend its territory. In Washington, Congress appropriated $10 million and authorized the deployment of ten thousand troops if war were to break out.

The British took steps at the same time to not only defend their vast timber interest but also to protect their travel route between Quebec and their Atlantic province of Nova Scotia. To achieve their goal, they established a series of garrisons to guard against an American invasion.

Although tensions mounted, and a few people from both sides were held captive, no muskets were fired in battle. Cooler heads prevailed, and conflict was avoided by diplomacy. The Webster-Ashburton Treaty, in addition to resolving the territorial dispute between Maine and the British colony of New Brunswick, also defined the border that stretches along the Great Lakes separating Canada and the United States.

9
THE WRECK OF A CIRCUS SHIP

THE *ROYAL TAR* STEAMER

The *Royal Tar* was a pioneer steamer that was to be the flagship of a newly established shipping route between St. John, New Brunswick and Portland, Maine. The route's importance was due to the fact that it provided passengers with a connection to Boston. It also enabled a passenger to go from St. John to New York in two and a half days—exceptionally fast travel time for that era.

The ship received its name in honor of the ruling British monarch, King William IV, "The Sailor King." It was built at the William and Isaac Olive shipyard in Carleton, New Brunswick, and launched in November 1835. The *Royal Tar* had a 146-foot keel with a deck of 160 feet and a 24-foot beam and cost approximately $40,000. Its owners included John Hammond, who held a half interest. The other partners were Daniel McLaughlin and the Mackay Brothers & Co. The ship's captain was Thomas Reed.

On June 5, 1836, the *Royal Tar* made its maiden voyage from St. John to Eastport, Maine, and St. Andrews, New Brunswick, and then made its return to St. John in a record time of less than five hours.

Next, she was put on scheduled runs between St. John, Eastport and Portland once a week and on a weekly river run between St. John and Fredericton, New Brunswick. This arrangement was maintained throughout the summer and into the fall.

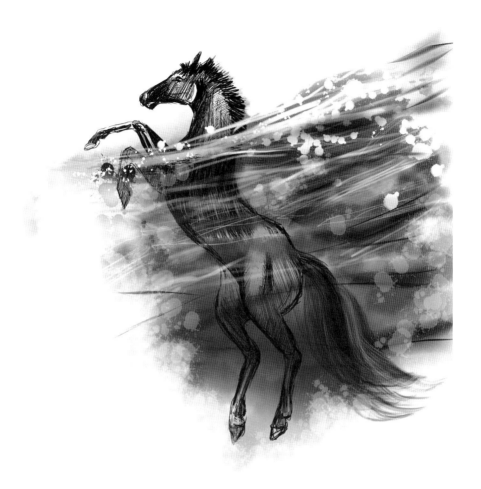

THE FINAL VOYAGE

Due to heavy weather along the Down East coast, the *Royal Tar* did not leave St. John until Friday, October 21. She had onboard for this trip a larger list of passengers than normal, as well as "Fuller's Menagerie," a group of animals belonging to the Burges and Dexter Zoological Institute. This group was heading home to the United States after having performed shows in Nova Scotia and New Brunswick. The ship had a crew of twenty-one, plus seventy passengers, including a number of women and children. The animal contingent had an elephant, two camels and a variety of other wild animals and birds. To support the exhibit's logistical needs, there was a large

number of cages, as well as wagons and horses to draw them. The *Royal Tar* resembled Noah's Ark as it steamed out of St. John on the first leg of its trip to Eastport. That evening, when the *Royal Tar* embarked for Portland, the wind was blowing so hard that Captain Reed decided after a short sail to drop anchor in Little River for safety. The gale conditions remained for three days. On the afternoon of October 24, the sea appeared to have become calmer, so the captain resumed the ship's voyage. After traveling a relatively short distance down into Machias Bay, they found that the sea had become quite angry, and the wind was blowing at a near gale force. Captain Reed concluded that safety demanded that he again drop anchor. When things calmed down on October 25, the *Royal Tar* once again commenced its voyage. Things appeared to be going well until the afternoon, when the ship's engineer found that the water in the boiler had gotten dangerously low. When the captain received this news, he ordered that the engine be stopped and the safety valve opened. The fire in the furnace was then put out. The force pump was turned on to supply more water to the boiler. Theoretically, this should have solved the problem.

The Shipwreck

Unfortunately, the problem had not been solved, and a short time later that afternoon, a fire was discovered under the deck over the furnace, near the area housing the animals. A great effort was made by the crew to extinguish the flames, but their efforts were futile and the fire continued to spread, placing everyone in jeopardy. Passengers were screaming at the horror of the conflagration, while the scared animals were roaring from fear. The only hope for survival was with the two lifeboats on board, and these were capable of saving only about a third of the passengers. Captain Reed and two crew members lowered a small boat and got into it in order to prepare rafts and save as many people as possible. At this time, a small group of selfish men took charge of the larger quarter boat, lowered it and rowed off to safety on the Isle Haut. Some brave passengers were compelled to try and save the poor animals. They were able to push the two camels and several of the horses overboard. The elephant when freed from his quarters, panicked from fear and ran to the side of the ship and jumped overboard. His plunge into the water resulted in upsetting a makeshift raft that had been holding a number of passengers, causing the drowning of several of these folks. None

of the animals that were able to make it overboard swam to safety. The animals left on board perished from smoke inhalation.

Fortunately, a U.S. revenue cuter under the command of Captain Dyer was able to rescue forty of the *Royal Tar* passengers. Despite everyone's efforts, thirty-two souls were lost.

Through the years, the story of this horrific Down East shipwreck has been documented in numerous books and periodicals.

THE GHOST AT LITTLE ROUND TOP

SCHOLAR, SOLDIER AND STATESMAN

Joshua Chamberlain is a true American hero and one of Maine's greatest citizens. He was born in Brewer on September 8, 1828. As a young boy, he was shy and studious. During his teen years, he held jobs working in a brickyard and as a lumberjack.

He left the workforce after a short stint and was accepted to Bowdoin College in 1848. After graduating in 1852, he pursued a program of theological training for the ministry at Bangor Theological Seminary. Upon completion of his studies there, he accepted a teaching position at Bowdoin.

In 1855, he married Francis "Fanny" Adams. He continued his teaching career at Bowdoin in the years leading up to the Civil War.

PARANORMAL EVENTS AT GETTYSBURG

Joshua Chamberlain's father was a man interested in military events and history. He introduced his son to these interests at a young age. The son was upset by the approaching winds of war, and after the Southern states seceded from the Union and war broke out, Chamberlain wanted to be involved. He contacted Maine's governor and communicated his

interest in serving. In August 1862, Governor Israel Washburn appointed him to the rank of lieutenant colonel of the Twentieth Maine Volunteer Infantry Regiment.

Chamberlain and the Twentieth Maine served with distinction in the very bloody battle at Chancellorsville, and he was promoted to colonel.

The Civil War continued into 1863. The armies were organizing for battle near the small town of Gettysburg. The Twentieth Maine arrived in the area at dark after a long day's march. When Chamberlain and his officers reached a fork in the road and were not sure which way to go, suddenly, the clouds that had darkened the sky parted and the moon lit up the road and illuminated a man cloaked in Revolutionary War dress on a beautiful white horse. He turned on his horse and waved, beckoning Chamberlain and his officers to follow. They followed this horseman to the spot they needed to be. Many of the officers commented that the figure who came and led them looked a lot like a painting of George Washington that they had seen. Joshua Chamberlain in his book *Through Blood and Fire at Gettysburg* recorded this strange event.

On July 2, Colonel Chamberlain was given orders to hold the strategic heights of Little Round Top. Waves of Confederates, under the command of General James Longstreet, kept charging the Twentieth Maine. Gunfire was all around them, and the battle soon got even bloodier with hand-to-hand combat. Suddenly on the battlefield, men on both sides saw a tall man dressed in a uniform of the American Revolutionary War style and a tricorn hat, riding a large white horse. The Confederate soldiers fired at this figure, but their bullets seemed to miraculously pass through him. The sight of this unknown soldier provided the men of the Twentieth Maine with a sense of strength. With bayonets fixed, they charged the shocked Confederates. Their bravery held the day for the Union.

Men on both sides of this horrific conflict were eyewitnesses to the event and believed it was George Washington astride the horse, leading his troops in defense of his nation.

Another paranormal event concerning George Washington and Gettysburg was documented by his aides during his encampment at Valley Forge. At that time, Washington told of a vision he had seen, of a horrendous battle, which they documented. One wonders if Washington's vision was that of the Little Round Top?

AFTER THE WAR

By the end of the war, Chamberlain had risen to the rank of brigadier general. Ulysses S. Grant had him accept the weapons that were surrendered by the Confederate army. Chamberlain showed his true humanity by ordering his troops to stand at attention in respect for the Confederate soldiers as they passed.

Upon returning home to Maine, he entered the political world and was elected to four terms as governor. Upon completing his fourth term, he became the president of Bowdoin College.

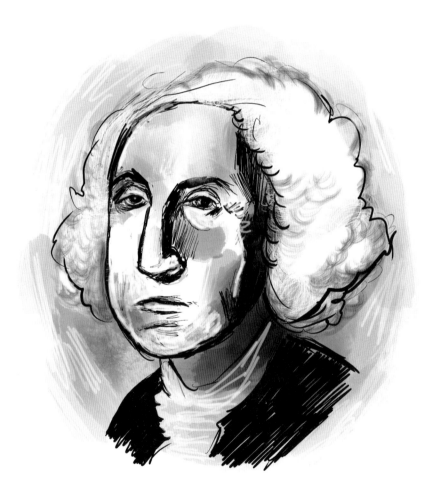

11

O'MAHONEY'S RAID

The Stage Was Set

During the seventeenth century, the British Crown became more aware of the strategic vulnerability that Ireland potently posed if either France or Spain should decide to invade England from the west through Ireland. Religion also played a role. After Catholic King James II was deposed and replaced by Protestant King William of Orange, trouble finally blew up in a full-scale war between these two forces. On July 1, 1690, the Battle of Boyne was fought. At the end of the day, the forces of Protestant William III were victorious. This led to the surrender of Irish forces to the British at Limerick.

In 1695, the British Parliament passed a series of punitive laws against the Catholic population of Ireland that were draconian. These harsh laws reduced the Irish to serfdom and allowed them to just eke out a living as tenant farmers for absentee British landowners.

In 1845, a blight struck the potato crop of Ireland and most of Europe. Potatoes were both a prime agricultural crop in Ireland and a cheap product for local consumption. Due to the economic system, most of the produce and animals were exported, leaving only a small fraction of the produce for locals. The Great Potato Famine had begun. More than one million Irish died of starvation, while more than two million emigrated. About 70 percent of the émigrés came to the United States, with most settling in cities in the Northeast.

The famine clearly made an indelible mark on the Irish and fostered a strong feeling of nationalism.

Soldiering

Many of the Irish found that they were not welcome in this new country. A secret group calling itself the "Know Nothing Party" was dedicated to opposing immigration. It had a special fervor against Irish Catholics and, at a minimum, wanted to keep these immigrants segregated and out of the mainstream. The outcome of these efforts was that it was very difficult for these new arrivals to find anything but the most menial of jobs. Boston was a particularly difficult place for the Irish in the 1850s.

The rumor of the southern states seceding from the Union was growing during the period. Following the election of Abraham Lincoln, South Carolina started the process that threw the nation into the Civil War.

The Union needed to build up its army, so a draft process was put in place to select young men to serve. An option was provided that many young men from wealthy families chose. They could purchase their way out of the draft by paying someone else to serve for them. Many young Irishmen thought that this was a golden opportunity, a kind of "luck of the Irish" to pick up a large piece of change. The going rate for replacing one of these rich boys could be as high as $1,000. The average annual national wage at the time was $500. Many new arrivals were soon serving in the Union army and involved in all of the war's horrendous battles. Those who survived the war returned to the urban centers they had left.

Rehearsing

Irish Civil War vets found friendship in the growing Fenian movement. This band of brothers' goal was to overthrow British rule in Ireland. The organization was started in Ireland in 1850 but moved out to the United States and Canada. By the end of the Civil War, there was a number of these revolutionary groups. Boston had a large number of Irish vets who were anxious to see their homeland freed of the British and were attracted to this emerging brotherhood. John O'Mahoney was the leader of the Boston

chapter. The Fenians developed a three-pronged strategy that involved the capturing of neighboring British Canada and holding it hostage as a bargaining chip to free Ireland. The Boston group was tasked with the strategy of putting together a military force to capture Campobello Island, New Brunswick.

One of the many flaws to this strategy was that the news of their plans leaked like a sieve. Secrecy is a standard requirement for a clandestine operation, but it wasn't to be the case for this venture.

The Final Scene

In April 1866, a ragtag group of Fenian warriors from Boston under the command of John O'Mahoney arrived in Lubec, Maine, readying to cross the narrows and invade Campobello Island.

In the port of Halifax, Nova Scotia, Commander Charles Hastings Doyle of the British Royal Navy, knowing of the Fenian plan to invade Campobello, set sail for Passamaquoddy Bay with several warships carrying some seven hundred regular British troops. Their arrival on the scene discouraged O'Mahoney's raiders. The planned venture has become a footnote to history.

THE MYSTERIOUS BILLY SMITH

Early Life

If you love a mystery, you will enjoy the mystique surrounding the life of legendary boxer "Mysterious" Billy Smith. His place and date of birth are both noted as being questionable. The following three locations have been nominated as his birthplace: Eastport, Maine; St. John, New Brunswick; and Little River, Nova Scotia. His date of birth has been recorded as May 15, 1871, while a Canadian census records his birth as May 15, 1872. His parents, Robert and Adelia (Dakin) Smith, were of Irish Canadian heritage. The best data leans in favor of his birth being at Little River.

Next, there is the question of his name. His Christian name was neither William, Bill nor Billy but, rather, Amos. His father was a fisherman. Amos appears to have moved around quite often, from Nova Scotia to St. John to Eastport, Maine. Several of Billy's siblings were definitely born in the Eastport area. As a teenager, Billy was known to be a thick-necked, square-jawed, broad-shouldered, tough kid who worked on the local docks.

A Career Pugilist

One early tale about Smith comes from New Orleans, where he was allegedly observed watching a sparring bout and asked if one of the guys

sparing was Jack Dempsey. The year was 1890, and Dempsey wasn't born until 1895. A more believable story in the same year was reported from Boston by a Captain Cooke, editor of the *Police News*, who claimed a young guy named Amos Smith from Eastport had stopped by his office looking to get booked for fights with local welterweights. It is claimed that he had a few fights in Boston as Amos Smith and lost miserably.

After his boxing debut in Boston, it is believed he had a few bouts in St. John, New Brunswick, in 1891 before heading west. His fortunes in the ring turned more favorable on the Pacific Coast. Over a period of time, there were reports of a fighter named Billy Smith winning bout after bout in San Francisco and Portland, Oregon. In 1892, Smith claimed the welterweight championship of the world. When news reached Boston, Captain Cooke at the *Police News* asked, "Who the hell is this Mysterious Billy Smith?" This new moniker stuck for the rest of his career.

Smith was considered to be a very talented fighter, a real brawler who was extremely rough and dirty when attacking his opponents. Mysterious Billy Smith's illustrious boxing career extended from 1891 to 1902. During those years, he fought in cities across the United States, as well as in Glasgow, Scotland, and London, England. Among some of the famous fighters of the time Billy Smith defeated were Joe Walcott, Al Neil, Billy Armstrong, Frank Purcell, George "Kid" Lavigne, Charles Gleason, Jim Judge, Mike Dempsey,

Danny Needham and Johnny Gorham. After winning his welterweight championship in 1892, he defended his crown in 1893, 1894, 1895 and the years through 1900.

Mysterious Billy Smith left the ring in 1902.

LIFE AFTER THE RING

Smith retired to Portland, Oregon, where he ran a saloon for many tears. He died on October 16, 1937, in Portland. His life's story and ring records leave many questions unanswered. He was truly a man who lived up to his nickname.

THE LEGENDARY CHESTER GREENWOOD

EARLY LIFE IN FARMINGTON

Chester Greenwood was born on December 4, 1858, in Farmington, Maine. At that time, the community was known for being a rural farming area that produced a significant amount of New England's wool from its large herds of sheep as well as apples from its many orchards.

Young Chester was an outdoor enthusiast and an avid skater. Each winter, he would ply the ice of the local ponds. Unfortunately, Chester was prone to frostbite, especially to his ears, and he couldn't wear a woolen hat as protection, as he had an allergy to wool. As is often cited, "Necessity is the mother of invention." This was certainly the case for young Chester. After a spin on the ice at a local pond on a frigid winter day, he returned home with freezing ears but also with an idea about how to solve his dilemma. He told his grandmother that if she sewed a small pad of flannel or beaver fur (some dispute exists over which was proposed) onto the circular ends of a wire ring, the newly created device would hold to his ears and solve the problem.

At age fifteen, with his grandmother's help, Greenwood had an invention. He applied for and won a patent for his new creation.

CHESTER THE ENTREPRENEUR

Over the next several years, Chester devoted his efforts to enhancing his original invention. Some of his technical changes included using bands rather than the wire rings and developing a technique to better place pressure against the ear, as well as to make the device more portable.

Despite some initial ridicule and scorn, some of the locals tried them and found that his winter ear protectors worked quite well. His new product, which we call "earmuffs," became a hit as "Champion Ear Protectors." He produced and shipped them from his local factory.

By the early 1880s, Chester's factory was employing eleven full-time workers. He also employed local women to do hand-stitching at home, as his grandmother had done on his original creation. In these early years, his factory was turning out around fifty thousand products annually.

During World War I, his factory geared up in order to provide earmuffs to thousands of troops fighting in Europe.

Chester Greenwood's genius as an inventor was formerly noted by the Smithsonian Institution, which has cited him as one of America's Outstanding Inventors. He is credited with more than 130 patents. Among his other inventions are a mechanical mousetrap and a whistling tea kettle.

Other accomplishments during his sixty-year career were the operating of a bicycle shop, the sales and distribution of Florida Boilers and being instrumental in operating the Franklin Telephone and Telegraph Company.

Chester's Legacy

The legendary Chester Greenwood passed away on July 5, 1937. He has never been forgotten for his lifetime contributions to his hometown of Farmington.

Since December 4, 1976, the Franklin County Chamber of Commerce has hosted the annual Chester Greenwood Day. The celebration honors the Farmington icon with a parade, a 5k race and all kinds of great food. Regardless of the cold or snow, thousands come out to participate in this special event.

14

THE MIDAS SCAM IN LUBEC

THE FRAUD DUO

Prescott Ford Jernegan, the son of a sea captain, was born in Edgartown, Martha's Vineyard, Massachusetts, in 1866. His boyhood friend from Edgartown was Charles Fisher. The two remained close into adulthood. Jernegan became an ordained Baptist minister, but the two had other career plans in mind.

In October 1897, the two arrived in Lubec, Maine, to set in motion an elaborate plan to defraud potential investors of thousands of dollars by selling shares of stock in their newly founded venture, Electrolytic Marine Salts Company.

To launch their scheme, they leased Hiram Comstock's tidal gristmill in North Lubec. Here they said their endeavor would successfully extract millions of dollars in gold from seawater running through their site. They claimed the extreme high tides of the area were what made the location so favorable. Jernegan also claimed that the whole endeavor came to him in a vision.

The Plot Thickens

During the period from October 1897 to February 1898, Jernegan and Fisher hired approximately one hundred men to convert their leased gristmill into a gold-extraction facility. They established a machine room and a laboratory, and in the water beneath the facility, they placed specially designed wooden boxes that they called accumulators to collect the gold from the seawater that flowed through them. Outside the facility, they installed a large wooden fence with barb wire and had "No Admittance" signs posted to ensure their operation was kept secured.

The alleged gold extraction was accomplished by placing 240 of the accumulators in the inlet to the millpond, and then through a "magical process" of having the fast-running water pass through their electro-chemical formula, gold was created. Their scheme called for each accumulator to spend one month in the water; each week, sixty units were to be pulled up and the gold extracted. To create a reality to their fraud, Charles Fisher, an active diver, would dive down and feed the boxes with some gold dust. When the accumulators were raised and the planted gold removed, it was showcased to onlookers and then sent to New York to provide verification of the treasure to potential investors.

Jernegan and Fisher designed a formidable prospectus stating that enormous wealth—perhaps as much as $100 million—could be realized from their Lubec venture. Thousands of shares were sold to investors across the Northeast.

So successful was their initial stock offering that they pushed their scam forward by constructing a second facility. They called these facilities Klondike Plant 1 and Klondike Plant 2. More than seven hundred laborers were involved in the construction work. Many of these workers were Italian immigrants who had been working in Machias on the railroad. Higher wages attracted them to this project.

On July 29, 1898, news circulated around Lubec that both Prescott Ford Jernegan and his sidekick, Charles Fisher, had mysteriously vanished. Work was suspended at both plants, and the realization came that an enormous scam had been pulled off.

REPORTED OUTCOMES

The local Lubec *Herald* reported that all seven hundred men were left without a job and the town's hope of a wealthy future had been dashed. Newspapers across New England highlighted the fraud. At the same time, Prescott Ford Jernegan and his family were sailing under an assumed name to France. What happened to Charles Fisher remains a mystery.

Jernegan and his family moved on to Brussels, Belgium, and while there he returned $75,000.00 to his investors. Based on the sale of the company's Lubec assets, the stockholders received $0.36 on each $1.00 of their investment. Further news reported that Jernegan went to the Philippines, where he became a teacher and authored a book on the Philippine islands.

Prescott Ford Jernegan died at the age of seventy-five on February 23, 1942, in Galveston, Texas.

For more details about this tale from Down East, see *The Great Gold Swindle of Lubec, Maine* by Ronald Pesha (The History Press, 2013).

"TALL BARNEY" OF JONESPORT-BEALS ISLAND

HIS HOMETOWN AREA

Jonesport is a small seacoast town on a peninsula at Chandler Bay and beside English Bay in Washington County. It was settled in the years before the Revolutionary War and was originally a part of Jonesboro under a grant given to John Jones and other settlers by the Massachusetts General Court. In February 1832, it separated from Jonesboro and incorporated as Jones' Port. A bridge across the Moosebec Ridge connects the town of Beals Island to Jonesport. The two communities are tightly coupled not only geographically but also in all phases of life.

The iconic "Tall Barney" was born on Beals Island on December 13, 1835. His parents were Barnabas Coffin Beal and Lucinda D. Beal. The Beal family was among the first to settle on the island in the mid-1700s.

A LEGEND IN HIS OWN TIME

Folklore abounds concerning this giant of a man. "Tall Barney" stood a good six feet, seven inches tall with broad shoulders and a huge chest. It is alleged that when sitting at his kitchen table, his arms dangled to the floor, allowing him to drum a tune on the floor with his fingers.

As for most folks of the area both then and today, the sea is a way to earn a livelihood. Some pull lobster traps, while others dig clams or drag for muscle, scallops and quahogs. In earlier times, many were engaged in trapping schools of sardines and in boat building. Tall Barney was no exception: he was a Grand Banks fisherman. In recognition of his folklore tradition, the Smithsonian has included in its exhibitions Tall Barney's fishing log of 1858.

Barney is credited with hauling a two-hundred-pound barrel out of his vessel's hatchway without the use of any tackle equipment. Another barrel feat he was noted to have accomplished was to have lifted a huge barrel full of water to have a drink. A local ballad has a verse showing how he easily settled arguments.

One of the legends surrounding his sleeping arrangements states that when he went to bed, he was forced to stick his feet out the window.

Oral tradition claims that he died on February 1, 1899, on Beals Island at age sixty-three from heart strain as a result of lifting a heavy load. A seven-foot monument marks Tall Barney's resting place at a local cemetery.

Tall Barney's Legacy

In 2011, the Beals Heritage Center was opened. Here, one can acquire *Tall Barney and His People,* a one-volume book that the Beals Historical Society has combined from two books, *Tall Barney Genealogy* and *Tall Barney the Legend,* authored and published by Velton Peabody. The center's mission is to preserve and expand the area's marine heritage by showcasing both its fishing and boatbuilding traditions.

For many years, a low-slung, one-story building on Main Street in Jonesport with a mammoth statute of the legendary Tall Barney beckoned locals to drop into the eatery of the same name, grab a coffee and breakfast, sit down at the famous "liar's table" and swap stories. From the crack of dawn at 4:00 a.m., fishermen, clam diggers and other locals piled into this iconic spot for good food and humor. The same atmosphere was provided to the locals for lunch and dinner, seven days per week.

On occasion in the summer months, a person "from away" would discover this Down East gem and enjoy a great meal and some wonderful local color. Unfortunately, this remembrance to Tall Barney is long closed and is but another legend.

Jonesport-Beals High School, although very small in terms of its student body, has been over the years a perennial basketball powerhouse. In 2012, a direct descendent of the legend, Garret Beal, became famous in his own right, leading the Jonesport-Beals Royals to a Maine State Championship. Garret's excellence on the court resulted in *Parade* magazine selecting him as a U.S. High School All-American. Upon graduation from Jonesport-Beals High School, Garret Beal transitioned to play at the University of Maine.

Big people live on and continue to make their community proud.

16

THE MOXIE NATION

SOME SURPRISES

When folks across America ask for a pop or a soda, they usually ask for a Coke, Pepsi or Dr. Pepper. In Maine, a different thirst-quenching beverage is often requested by a legion of faithful Moxie enthusiasts. It is not surprising that Moxie, with its unique flavor that some say is bitter in comparison to the sweeter carbonated soft drinks, is not known outside of New England.

It was not always this way. Moxie was actually the first carbonated soft drink, beating out both Coca-Cola and Dr. Pepper. It was also America's most popular soft drink through the early 1920s. Pepsi did not come along until years later. Moxie was not introduced as a soft drink but as a patented medicine that would cure all types of nerve disorders and nearly everything else, including impotency. Initially, this original elixir was taken by spoon as a medicine. It was not created in Maine, as some legends claim, but in Lowell, Massachusetts.

HOW IT ALL BEGAN

Moxie's creator, Augustin Thompson, was born in Union, Maine, on November 25, 1835. Through the years, Union has been called the home

of Moxie, and this is probably the reason for the legend that Moxie was created in Maine. As a young adult, Thompson was an abolitionist. He volunteered for service in the Union army on October 1, 1862, and within several days of his enlistment, he was commissioned a captain of Company G, Twenty-Eighth Maine Volunteer Infantry. He served honorably in several battles against the Confederates but developed tuberculosis and was given a medical discharge. After about a year in recovery, he was able to rejoin the military, and he served with his Maine unit with distinction until it was discharged on July 6, 1865.

After the war, Thompson enrolled at the Hannemann Homeopathic College in Philadelphia. He was a brilliant student and graduated number one in his class. Upon graduating, he returned to New England and opened his medical practice in the burgeoning industrial city of Lowell, Massachusetts. His practice soon took off, and he became known as a very successful doctor. A wealthy friend, who, like Thompson, had contracted tuberculosis, searched the world for a cure for this disease, rampant at that time. In the mountains of South America, natives introduced him to a medicinal root we know as gentian root. He found that they used it to cure all types of health problems.

His friend shipped him a supply of the medicinal root together with the information that he had obtained from the native people. Thompson experimented with this new product and found that it lived up to its curing reputation.

With his newfound knowledge concerning the healing powers of this medicinal root, Thompson filed for a trademark on July 16, 1885. His application documented the product's attributes as "a liquid preparation charged with soda for the cure of paralysis, softening of the brain, and mental imbecility and called 'Moxie Nerve Food.' It is comprised in the class of medical compounds."

Where Thompson came up with the name *Moxie* is unknown, although a number of options have been suggested. It really didn't matter, because Moxie was a winner right out of the box.

Dr. Augustine Thompson soon had to give up his lucrative medical practice and devote his full attention to Moxie. The product was reformulated, repackaged and marketed as a carbonated soft drink. Sales nationwide continued to soar into the early 1920s.

Moxie's popularity nationally started tracking off as people's preference for a sweeter beverage gained popularity in the 1930s and '40s. Like Red Sox fans, New England Moxie devotees—especially Mainers—keep Moxie's mystique alive as members of the Moxie Nation who love its distinctively different taste.

MAINE CELEBRATES MOXIE

Maine is known for having some interesting festivals honoring all kinds of foods, from clams and lobsters to whoopee pies, but Lisbon Falls has been hosting its own special beverage festival for more than three decades. The annual Moxie Festival is a three-day celebration in mid-July.

Frank Anicetti, who was known as Mr. Moxie in Lisbon Falls, was the person who launched the celebration of this unique beverage. Although Frank has passed away, his memory lives on through the festival he helped start. In addition, all the locals recall how his Kennebec Fruit Company store was also a museum filled with Moxie memorabilia.

Today, Frank's store is a restaurant, and the current owners honor Frank's memory by keeping the walls decorated in Moxie orange.

Moxie is also acclaimed to be very special by the State of Maine. On May 10, 2005, it was designated by proclamation as Maine's official soda.

As Red Sox great Ted Williams stated in a long-ago ad, "Make Mine Moxie." Continue to enjoy Maine's favorite beverage.

THE GARRYOWEN LEGEND

Personal Disclosure

This is a story about a Maine environmentalist, philanthropist, politician, visionary and animal lover. His faithful Irish Setter companion, Garryowen (better known as Garry II), became famous during the years that he served as governor. Garry II's owner, Governor Percival Proctor Baxter, a Maine icon, was proud to share the stage with his faithful canine.

I can personally relate to this story, even though I never knew either the governor or Garryowen. Rather, it is as a recipient and lover of the governor's generous gift of Baxter State Park and my involvement with dogs. My father bred and showed Wire Haired Fox Terriers. I have been fortune enough to have had dog companions my whole life. I have had a number of fantastic dogs, mostly terrier breeds, including Airedales and Irish and Welsh terriers. For more than forty years, my late wife, Jane, and I raised and showed Kerry Blue Terriers. We also operated a small boarding kennel in Boothbay for a number of years. Now my constant companion is Duncan, a little Scot—a West Highland White Terrier who is sitting next to me as I key this story.

Now that I have provided my personal disclosure, I can move on with the legend.

A MAN AND HIS DOG

Percival Proctor Baxter was born into a wealthy Portland family on November 22, 1876. His father was James Phinney Baxter, and his mother was Mehitable Proctor Cummings Baxter. His father was involved in the family's canning business and was also a dedicated history buff. Young Percival attended local Portland schools, but during his growing years, his father took the family to England so that he could do historical research on early New England documents archived there. Percival completed his education in England.

Upon his return to Maine, he enrolled at Bowdoin College and graduated with honors in 1898. Next, he went on to Harvard Law School, where he earned a law degree in 1901.

Rather than proceed with a legal career, he chose to enter the family business. Percival's business acumen substantially helped the enterprise flourish. After a short few years, he was ready for an additional challenge. In the fall of 1906, he successfully ran for a seat in the state House of Representatives. Upon completing his first term in the house in 1909, he decided to run for the state Senate. Again, Percival campaigned successfully and won a Senate seat. In the election of 1910, the Democrats scored a major statewide victory; Percival lost his reelection bid.

Baxter stayed on the political sidelines until 1916, when he again ran successfully for a seat in the state's lower house. Upon completing that term, he again sought a seat in the state's upper chamber. He not only successfully won a Senate seat but was also soon chosen president of the state Senate.

He almost immediately moved up from the presidency of the Senate because the recently elected governor, Frederic H. Parkhurst, became ill and died after being governor for only a few hours. Under Maine's constitution, the president of the Senate succeeds a governor if he or she can no longer perform the governor's duties. Baxter served out that term and was reelected for a second term in 1922.

Garryowen (Garry II) was Governor Baxter's constant companion. The dog would travel each morning from the Blaine House to the governor's office, where he would relax on a couch close to the governor's desk. When Governor Baxter took walks with Garry II around the Augusta neighborhood, children would stand along their regular route to greet them and hope to pat Garry or shake his paw.

When Garry II died at the capitol at age nine, the heartsick governor requested that the flag at the statehouse be lowered to half-staff in his

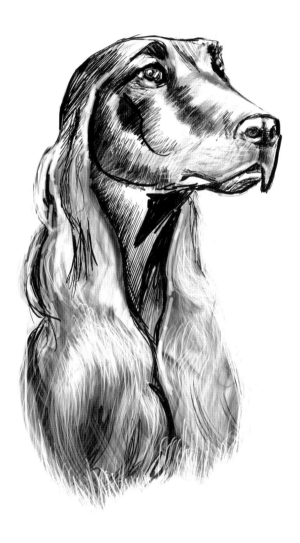

honor. The news of the flag lowering brought angry responses from veterans groups as well as national and international newspaper headlines.

Percival Baxter was active in several humane societies across the country, including in New England. He loved his beautiful, rich chestnut red–coated setters and wrote and published a book devoted to his canine friends, *My Irish Setters*.

The Nineteenth Amendment, which passed in 1919, granted women the right to vote. It was quickly honored by the visionary Baxter, who took the opportunity during his governorship to appoint women to some key administrative posts.

Percival Baxter was the first governor to climb the majestic Mount Katahdin. At the height of the Great Depression, he began acquiring land around the mountain that would become part of his legacy. In 1962, he put the last pieces of this wilderness preserve in place. He gifted this environmental gem to the citizens of Maine.

A Discovered Legacy

During the restoration of a World War I memorial, workers on the project uncovered a metal box that had been buried at the site. The workers turned it over to state officials. Opening the box, they found the type of historical documents they expected, but they also found a sealed envelope that had printed on it "to only open after my death—Percival P. Baxter." The officials gave the envelope to the governor, Angus King. He made arrangements to read the eight-page document to Baxter's descendants. His letter provided a clear picture of his ethical and spiritual views. He was very antiwar, and he explained that he never married because the love of his life had turned him down. His letter detailed the shock he felt for the neglect and cruelty shown to animals in Maine and how he believed that kindness should be shown to every living creature.

He also commented on his decision to lower the flag at the statehouse for Garryowen when he died: "Good old Garry II was the first dog in history to be thus honored," Baxter wrote. "His spirit lives on and through him, dumb animals the world over will be treated more kindly and mercifully."

Percival P. Baxter's last eloquent words are those of a great humanitarian leader.

THE MISSING WHITE BIRD

A New Mystique

At the dawn of the twentieth century, the fantasy of flight was realized at 10:35 a.m. on December 17, 1903, at Kitty Hawk, North Carolina, when Orville and Wilbur Wright's dream of flight was realized. To achieve this technological breakthrough, they had to design nearly everything, including the engine and propeller. This achievement paved the way for more successful adventures in the sky.

World War I saw the use of airplanes as weapons of war. Aviators like Germany's Manfred von Richthofen (the "Red Baron"), France's flying ace Charles Nungesser and the American flyers of the famous Lafayette Escadrille were the superstars of their day. Their feats pushed for even more exploits in the air.

The Big Challenge

By 1917, not only was America fascinated with flying, but the U.S. Congress was also impressed enough with the progress that aviation had made that it appropriated $100,000 for a trial airmail service run. The first flight was a two-stage affair starting on Long Island, New York, and

landing in Philadelphia, Pennsylvania. The second leg of the flight went from Philadelphia to Washington, D.C. President Woodrow Wilson met this inaugural airmail flight.

Air service had become a more acceptable means of mail transportation by 1919. The availability of small, light planes, together with the enthusiasm of a number of courageous young men looking for a high-risk adventure, launched a new era in entertainment called barnstorming. Daredevil aviators would engage in high-risk air stunts above local fields across the country.

The real challenge of the 1920s was to make the first transatlantic flight. A prize of $25,000 was posted in 1924 by Raymond Orteig, a New York businessman, for any person or persons who could fly nonstop from France to the United States

Charles Nungesser, a flamboyant, French World War I ace, and his friend Francis Coli, another French World War I aviator, took up the challenge. Their plan was to fly the *White Bird*, a biplane they had designed and built, from Paris to New York City nonstop before Charles Lindbergh's planned trip.

On May 8, 1927, they took off from Bourget Field in Paris. Their flight plan took them over the English Channel, then over southwestern England and then into Ireland. They were spotted flying over Ireland and again off the Irish coast by an officer aboard a British ship. The next part of their flight was to be over water until they reached Newfoundland. Then, they would be heading toward their goal of New York City. On the morning of May 9, 1927, a number of folks in Newfoundland remember either seeing or hearing the plane winging along on its flight.

The mystery of the *White Bird*'s disappearance begins when the plane was heard in Down East, Maine. On the afternoon of May 9, 1927, Anson Berry of East Machias was out on a local lake fishing when he heard the sound of a plane's engine overhead. Due to the fog and overcast conditions of that afternoon, he could not see the aircraft. He noted that the plane's engine sounded erratic. Then he heard nothing. Due to the poor weather, he didn't follow up on what he had heard.

Others at the time believed the *White Bird* crashed at sea, yet nothing was ever found to substantiate that claim.

Like cold case crime investigators, aircraft researcher Rick Gillespie and his wife initiated a new search to solve the missing plane's disappearance in 1985. The Gillespie focus was back in the Washington County area where Anson Berry had thought he might have heard the

White Bird. They interviewed Harold Vining, a local blueberry farmer, who told them that on May 9, 1927, he was outside his home chopping wood when he heard the sound of an airplane flying overhead. Several miles from Vining's home they interviewed Everett and Abigail Scott, who told them that they were driving home from shopping when they heard the plane. They stopped their car and got out to be able to better hear the plane's engine. Another local woman, Mary Gould, stated to them that she was in her kitchen when she heard a plane fly over her home. While all of these people were credible witnesses to hearing what very well might have been the *White Bird*, no one has yet found actual plane wreckage. So the mystery remains, even though circumstantial evidence show a good possibility that the *White Bird* may have made the first transatlantic flight, beating Charles Lindbergh's successful flight on May 21, 1927, by twelve days.

THE *GREY GHOST* ERA

As Maine Goes, So Goes the Nation

The above subtitle was the phrase applied to Maine in the nineteenth and early twentieth centuries, because the state had become a bellwether for predicting the outcome of presidential elections. Maine lived up to this tradition by being the birthplace of prohibition in 1851, nearly seven decades before the Eighteenth Amendment, which banned the production, transportation and sale of alcohol. Excluded from the law were personal consumption and private possession, as well as its use for medical and religious purposes.

Civil War general and Portland mayor Neal Dow spearheaded the temperance movement here in Maine. He was also instrumental in making Maine legally "dry." Temperance leaders like Dow believed alcohol was the source of all society's ills. They were very vocal in stating their view that the hordes of immigrants arriving with their heavy drinking habits was creating an even worse problem.

While Dow touted the success of the experiment, many Mainers flouted prohibition and made booze in their home for themselves and to sell to neighbors in what were called "kitchen bars." Circumventing the law was an activity that was prevalent among Mainers across the state. Farmers took delight in making hard cider from their apple crop. Pharmacists and grocers sold liquor for alleged medical use.

President Teddy Roosevelt warned of the dangers posed by enactment of a national Prohibition act, but his warning went unheeded. The bill authorizing the Eighteenth Amendment was passed by Congress, as was the Volstead Act, over President Wilson's veto. This set in motion the start of American Prohibition on January 17, 1920.

A Cultural Transformation

The period directly following World War I saw the enactment of Prohibition, which was a prize long sought by temperance groups. But the times were changing. The postwar economy was booming, mobility was at a high pitch, Henry Ford had made cars affordable and new industries were bringing people to America's large cities, including a great migration of black citizens from the South to the North to achieve a better life.

Like Adam and Eve in the garden, God's prohibition on a fruit did not stop them from sampling it. The new Eighteenth Amendment seemed to provide the same motivation for Americans to drink. The early 1920s were characterized by new freedoms in all aspects of social, economic and cultural of life. Some saw this burgeoning era as an over-the-top period with the loosening of social morals and the rise of criminal involvement, including the running of speakeasies and bootlegging operations.

Prohibition helped launch a new cottage industry of rumrunning on Maine's Mid Coast and Down East. Most of the new entrepreneurs in this market were fishermen who saw a fast way to make an easy buck, smuggling in contraband booze. Many of these rumrunners were looked at as local heroes.

In Charlotte County, New Brunswick, which borders Washington County along the St. Croix, was a hotbed of smuggling. On any given night, protected by darkness, boats loaded down with liquor would make the crossing, unload the cargo and drive off to customers. The flow of revenue into New Brunswick was fantastic during the thirteen years of Prohibition.

Bucks Harbor Brand of Bootlegging

Edward "Ned" Flynn was born in Bucks Harbor in 1892. He grew up in a seafaring tradition, so it was only natural that Ned became a lobsterman. He was twenty-eight years old when the Eighteenth Amendment was enacted. The new law opened up a risky enterprise for those willing to take their chances rumrunning. One could make a lot of money bringing in booze in the stealth of night along the Down East coast, avoiding the law in the process. Ned Flynn of Bucks Harbor was a risk taker who was ready to test the system.

During the first five years of Prohibition, Ned Flynn, in his large, fast lobster boat, the *Grey Ghost*, plied the rugged sea between his home port and St. Pierre Island, a French possession located in Fortune Bay, about twelve miles south of Newfoundland. This is where Ned met up with his European providers of booze. The 120-proof liquor that he accepted from his supplier came in five-gallon tin cans. After loading his precious cargo onto the *Grey Ghost*, he had to make the long trek back to Down East, Maine. Back in his home area, he would carefully unload his cargo and connect with his Boston wholesale buyer. The buyer's drivers would pack the booze into their black Buicks that had the back seats removed so they could store the maximum amount of valued stock. They would then take off for Boston, where the booze would be placed into labeled bottles to be sold to speakeasies or private consumers. The priority for all involved in this process was to not get caught by the law. This was a tedious task for all involved in this dangerous business. On Ned's part, it required a lot of guts and great skill as a mariner to handle the rugged winter Atlantic in a relatively small boat.

Ned built his enterprise to handle the many contingencies that could occur. By the end of 1925, he employed a crew of three and had an informer in the local Machias Police Department who could give him a heads up if the Feds were close on his heels.

In 1926, he received word that operating out of Bucks Harbor was no longer a safe option, so he moved his business up the coast to L'Etete, New Brunswick. This small coastal community in Charlotte County, New Brunswick, is just a short distance by boat from Eastport. His new home port provided him with a safe harbor to operate from, as Canada had no prohibition laws. Ned settled into his new community and there met Bertha Tucker, a woman of Canadian Scottish heritage, whom he married.

His rumrunning business prospered. He continued to travel to St. Pierre Island to meet up with his European supplier and haul his prized

cargo back to Down East, Maine. On one occasion, he arrived in East Machias in a snowstorm. He and his crew unloaded their cargo and hid it in a snowbank to camouflage it until the Boston boys came to pick it up. Unfortunately, the snow changed to a driving rain, exposing the loot. One of Ned's informers spotted the problem, and the day was saved before the law noticed.

Ned Flynn managed to escape the law until 1933, when he was caught by the Feds unloading his cargo of booze on the Kennebec River in Machias. It was a strange bit of irony that his bootlegging days ended the very same year that Prohibition ended. Ned served a short jail sentence, and the Feds confiscated the *Grey Ghost* and a smaller white boat of his and put them up for auction. Ned was fortunate in that he was able to buy them both back.

Ned Flynn lucked out. He came through both the Prohibition years and the Great Depression physically and financially in good shape. He returned to his home in Bucks Harbor from L'Etete, New Brunswick, with his growing family and returned to lobster fishing.

His sons, Harley (now retired at age ninety-one) and George (who recently passed away), had both carried on the heritage as Bucks Harbor lobstermen. His great-grandsons are now carrying on this family tradition.

End of a Moral Experiment

Bookended between World War I and the Great Depression was the thirteen-year period of American lore that many today don't know much about. The tales they have heard of this era are based on books and Hollywood movies glamorizing the wild partying of the Jazz Age and the rise of mobsters in America. A realistic interpretation of the era, with considerable attention given to Maine's role, was found in Ken Burns and Lynn Novick's 2011 documentary *Prohibition*, which was aired on PBS.

Harley Flynn, my friend and neighbor, provided me with this illuminating story of his dad and the *Grey Ghost* escapades in rumrunning.

A BIZARRE BANK ROBBERY

A Strange Hometown Event

Mars Hill, Maine, is a small, rural community in central Aroostook County. Its population is under 1,500 citizens, and it has no major industries within its confines. It certainly is thought of as a very safe place, where a brazen crime could never happen. But on November 12, 1971, a local Vietnam vet pulled off the crime of the century in that small hamlet.

The Man

Bernard Patterson was like lots of kids growing up in the "County." He matured as a patriotic American and desired to serve his country in the Vietnam War. The 1960s was a tumultuous period, with unrest on many major college campuses. Bob Dylan's ballad "The Times They Are A-Changin'" aptly captured the mood of the country.

Against this backdrop, Bernard Patterson and thousands of other young Americans traveled halfway around the world to serve in the war. Among the 58,000 American casualties were 341 Mainers.

Patterson served with distinction in Vietnam as a tunnel rat and paratrooper and was awarded four Bronze Stars for heroism and recommended for a Silver Star for valor.

Like other servicemen returning home at that time, he was not welcomed as a hero but treated as a scapegoat. He was disillusioned, distrustful of government—especially the Veterans Administration (VA)—and no longer felt that he fit in.

THE ROBBERY

Having been turned down for a VA college loan, Patterson thought it was payback time. Thus his saga was undertaken. Disguised with a blue wig and wearing sunglasses and an ankle-length trench coat, he entered the Mars Hill Northern National Bank and demanded cash from the bank's elderly teller. Being a local in a small town, the teller recognized him in his ridiculous costume. Patterson stuffed his haul—over $100,000—into suitcases and left the bank, having pulled off the biggest bank heist in Maine's history.

A Wild Adventure

Patterson's outrageous escape began by his jumping into a rubber raft with all of his newfound wealth and paddling down the Prestile Stream. His wild venture took off from there, first across America and then to Europe, where he motorcycled from country to country. He had a knack for being able to talk his way by border guards. He lived high off the hog in France, England and Switzerland. His favorite destination was the skiing mecca of Villars-sur-Ollon, in the Swiss Alps. There, he rented a mansion during the height of the winter season and lavished himself with wine, women and song. His military training had provided him with the skills to successfully elude international law enforcement agencies. His remarkable motorcycle journey took him to Yugoslavia, and then he moved on to Morocco, North Africa. There, he purchased a camel and got lost in the desert. After eleven months on the run, he returned to England and ended his adventure by surrendering to Scotland Yard authorities.

The Final Chapter

While traveling twenty thousand miles through seven countries and three continents, Patterson managed to spend nearly all of the stolen money. He did give away some of the stolen money, but he was not as much of a folk hero as he has often been portrayed.

Bernard Patterson was prosecuted for his crime of bank robbery, convicted and sentenced. After serving several years in prison, he was released and returned to Aroostook County. Back home at last, he pursued farming. He died in 2003 at the age of fifty-six.

Maine native Ron Chase, an army vet of the Vietnam War, captured this remarkable tale in his book *The Great Mars Hill Bank Robbery* (Down East Books, 2016).

THE ALLAGASH ABDUCTION

THE ALLAGASH WILDERNESS WATERWAY

For well over a century, people have come to enjoy the thrill of camping and canoeing in a truly wilderness region. Mainers have long cherished and praised this area as a sportsman's paradise. Henry David Thoreau was awed by the beauty of the Allagash wilderness and believed it should be protected for future generations.

In 1969, Senator Edmund Muskie proposed an amendment to the National Wild and Scenic Rivers Act that provided for permanent protection for the Allagash. In July 1970, the federal government classified the Allagash as "Wild," the most restrictive category.

The waterway is ninety-two miles long with no permanent human inhabitants and is one of the finest canoe trip adventures to be found in America.

A PLANNED ADVENTURE

Four students of the Massachusetts College of Art & Design—brothers Jack and Jim Weiner and their friends Chuck Rak and Charlie Folitz—planned a two-week camping and canoeing adventure in northern Maine's Allagash

Waterway. Their wilderness destination was 450 miles from Boston. They arrived at their Allagash destination on August 22, 1976. The next day, they pushed off on their adventure.

Two nights into their trip, Jim spotted a strange bright object in the sky. It was there for only a few seconds and vanished.

Two days later, on August 26, the men had reached Eagle Lake. After they had set up camp for the night, they decided to do some trout fishing. Before going out on the lake they lit a bonfire so they could find their way back to their campsite. Unlike Boston with its light pollution, Eagle Lake got pitch dark at night. Shortly after they got on the lake and started to fish, Chuck said that he was getting this strange feeling that they were being watched.

Next, the men turned to the area from which Chuck felt the strange feeling was coming. They saw a large, bright object of colored light hovering soundless several hundred feet at the rim of the cove.

Then the men looked behind them and saw this huge glowing object rising above the trees. Its glowing light intensified and appeared to have a colored liquid form, making the oval object look somewhat like a boiling plasmatic substance. Charlie, being a brave soul, took out his flashlight and started signaling to the object. The object then came to an abrupt halt and began to slowly approach their canoe. A beam of light sprung from the object and hit the water. The beam began moving toward them. They started paddling toward their bonfire at breakneck speed. The beam swept across the lake and engulfed them.

The next thing Charlie recalled was their panicked paddling to shore and then standing at their campsite, watching this strange, large oval object disappear.

Other Accounts of the Incident

The brothers Jack and Jim recalled a bit more. Jack said that he remembered seeing the object directly behind them and advancing toward them so quickly that they would never be able to outrun the beam. He thought they would never get away. The next thing he remembered was them all getting out of the canoe on shore and looking directly at the object hovering about twenty or thirty feet above the water. Jack then said that the beam was coming directly out from underneath the object, as if the object was sitting on the beam. He said it remained there in front of them for about five minutes.

Jack said that suddenly the object's beam did a 180-degree turn upward in the sky and soon was gone toward the stars.

Chuck Rak's recollection was that he had stayed in the canoe, holding his paddle as everyone piled onto shore. He said that his eyes were fixed on the object.

Jim Weiner commented that there was no doubt the object was coming after them, but the next thing he remembered was standing on the shore watching it hover above the lake and not being able to speak a word.

Their Adventure Continued

Things settled down for the four men. They were safely back at their campsite, and they agreed that they thought their strange encounter had lasted about twenty minutes. What they couldn't understand was that they had placed logs on their bonfire that should have lasted for hours, but all that was left of their bonfire were some hot coals.

Another strange thing was that the four didn't spend any time discussing what had happened but, instead, said they were very tired and just wanted to hit the sack.

The next morning, Jack, Jim, Chuck and Charlie started their day off just like any other day on a fun adventure. They gathered up all of their gear, packed into their canoe and started back off on their Allagash Waterway trip. Their camping trip lasted another ten days, but during this period, they never had another encounter with the UFO that had tracked them down on Eagle Lake. So what had really happened to them?

The Next Chapter

As time passed, the four men told their story to family members and friends, but these folks all scoffed at the UFO encounter tale they were told. Jack, Jim, Chuck and Charlie began to have some doubts about the incident and began to think the whole thing was some sort of a weird nightmare they had all experienced.

Jack and Jim Weiner began having nightmares about their strange encounter and thought they needed some help. Jim sought out Raymond

E. Fowler, a nationally respected UFO author and researcher. Fowler served as director of scientific investigation for the Mutual UFO Network (MUFON), as well as a scientific associate for the Center for UFO Studies and chairman of NICAP (National Investigation Committee on Aerial Phenomenal). Ray received his bachelor's degree in liberal arts from Gordon College, graduating magna cum laude. After a stint in the U.S. Air Force's Security Service, he joined Sylvania Electronic System's Minuteman Missile Program, where he was responsible for overall program scheduling. I came to know Ray as an associate at that time, as I was then documentation manager for the Minuteman Program. Based on a six-year association with Ray, I can attest to both his integrity and research ability.

After Fowler had done an analysis of the incident that Jack, Jim, Chuck and Charlie had experienced, he recommended that the four undergo hypnosis by a professional psychologist to determine what actually happened to them during their Allagash abduction.

THE ABDUCTION REMEMBERED

The four men, independently of one another, told the therapist of terrifying experiences they had endured during their time on the UFO. The details recovered from the four while under hypnosis were almost exactly the same. It was an abduction by aliens.

They all described being taken onboard the UFO. Inside, they were put in an area they described as being akin to a doctor's office. It was in that part of the ship that the aliens took samples of their skin and body fluids.

The four men said that they could observe what the aliens were doing to their friends. Chuck Rak described that the aliens had a device they were using to suck something out of his neck while he had his head tilted back. He looked as if he was in pain, but there was nothing that Chuck could do to help his friend.

Each of the men described similar experiences while under hypnosis. Upon completion of their independent hypnotic sessions, they were told that each recalled very similar events during their abduction. Each of the men then took a polygraph test, and each passed it.

In spite of the evidence validating the Allagash abduction, skeptics still exist.

THE SCHOOLGIRL AMBASSADOR

School Days

Major transformational events happen during nearly everyone's childhood. American elementary school students during the 1960s and through the 1980s lived under the threat of nuclear war with the Soviet Union. To guard against a Soviet attack, air-raid drills were periodically practiced. A siren would go off, and kids would get under their desks and put their hands over their heads to protect themselves. This was an element of school life of that era.

The Girl

Samantha Smith was born in Houlton on June 29, 1972. Her Father, Arthur Smith, was at that time a professor of English at the former Ricker College, and her mother, Jane Goshorn, was a social worker with Maine's Department of Human Services. With Ricker College's financial future in doubt, Arthur Smith secured a teaching position with the University of Maine at Augusta, and the family moved to Manchester in 1980.

Young Samantha had a gift for writing, and she expressed this gift at the early age of five by writing a letter to Queen Elizabeth II, telling her how much she admired her position as a world leader.

In November 1982, Yuri Andropov succeeded Leonid Brezhnev as leader of the Soviet Union. The policy of détente had been abandoned, and the threat of a nuclear war was a scary possibility. The American media described Andropov as a strong and very ruthless person, detailing how he suppressed dissidents in Hungary during the 1956 uprising and how he was strengthening his new position by giving greater powers to the KGB.

On November 22, 1982, *Time* magazine featured the new Soviet leader on its cover, with an in-depth article covering his rise to power. After reading the feature article, Samantha Smith asked her mother, "If people are so afraid of him, why doesn't someone write a letter asking whether he wants to have a war or not?" Her mother replied, "Why don't you?"

Up for the Challenge

Following up on her mother's challenge, Samantha sat down and wrote to the Soviet leader:

> *Dear Mr. Andropov:*
> *My name is Samantha Smith. I am ten years old. Congratulations on your new job. I have been worrying about Russia and the United States getting into a nuclear war. This question you do not have to answer, but I would like to know why you want to conquer the world or at least our country. God made the world for us to live together in peace and not to fight.*
> *Sincerely,*
> *Samantha Smith*

Follow-up

Samantha received notification that her letter had been published in the Soviet newspaper *Pravda* but did not receive a reply from Andropov. Next, she sent a letter to the Soviet ambassador in Washington, D.C., asking if Mr. Andropov had taken time to read her letter and if he intended to answer her.

Andropov sent the following reply to Samantha on April 26, 1983:

Dear Samantha:

I received your letter, which is like many others that have reached me recently from your country and from other countries around the world.

It seems to me—I can tell by your letter—that you are a courageous and honest girl, resembling Becky, the friend of Tom Sawyer in the famous book of your compatriot Mark Twain. This book is well known and loved in our country by all boys and girls.

You write that you are anxious about whether there will be a nuclear war between our two countries. And you ask are you doing anything so that war will not break out.

Your question is the most important of those that every thinking man can pose. I will reply to you seriously and honestly.

Yes, Samantha, we in the Soviet Union are trying to do everything so that there will never be war on Earth. This is what every Soviet man wants. This is what the great Founder of our state, Vladimir Lenin, taught us.

Soviet people well know what a horrible thing war is. Forty two years ago, Nazi Germany, which strove for supremacy over the whole world, attacked our country, burned and destroyed many thousands of our towns and villages, and killed millions of Soviet men, women and children.

In that war, which ended with our victory, we were in alliance with the United States: together we fought for the liberation of many people from the Nazi invaders. I hope that you know about this from your history lessons in school. And today we want very much to live in peace, to trade and cooperate with all our neighbors on this earth—with those far away and those nearby. And certainly with such a great country as the United States of America.

In America and in our country there are nuclear weapons—terrible weapons that can kill millions of people in an instant. But we do not want them to be ever used. That's previously why the Soviet Union solemnly declared throughout the entire world that never—never—will it use nuclear weapons first against any country. In general we propose to discontinue further production of them and to proceed to the abolition of all the stockpiles on earth.

It seems that this is sufficient answer to your second question: "Why do you want to wage war against the whole world or at least the United States?" We want nothing of this kind. None in our country—neither workers, peasants, writers nor doctors, neither grown-ups nor children, nor members of the government—want either a big or little war.

We want peace—there is nothing that we are occupied with growing wheat, building and investing, writing books and flying into space. We

want peace for ourselves and for all people of the planet. For our children, and for you, Samantha.

I invite you, if your parents will let you, to come to our country, the best time being this summer. You will find out about our country, meet with your contemporaries, visit an international children's camp—Artek—on the sea. And see for yourself: in the Soviet Union, everyone is for peace and friendship among peoples.

Thank you for your letter. I wish you all the best in your young life.
Y. Andropov

AMBASSADOR SAMANTHA

Upon receipt of Yuri Andropov's letter, Samantha Smith became an overnight national celebrity. Newspaper, television and radio journalists flocked to interview her and find out all about her direct questioning of the Soviet leader.

Her parents were supportive of Samantha accepting Yuri Andropov's invitation to visit the Soviet Union, and on July 7, 1983, she flew to Moscow with her parents. While in the Soviet Union, she spent time in both Moscow and Leningrad and described the people she met as extremely friendly. She spent the most time at Artek, the children's summer camp. While there, she chose to stay in a girls' dorm with all Russian girls. The camp staff did select girls to room with who were fluent in English. She enjoyed her time swimming and learning about the Russian culture and making friends. At a news conference in Moscow, she told reporters that she found the Russians to be "just like us."

After a three-week adventure in Russia, Samantha and her parents returned to the United States on July 22, 1983. The red carpet was essentially brought out to welcome home Maine's young peace ambassador. Across the country, people were very impressed with the accomplishments of this young schoolgirl. There were a few who thought the whole thing was nothing but a public-relations stunt, but they were certainly in the minority.

Samantha's ambassadorial role continued, as did her media role. In 1984, she attended the Children's International Symposium in Kobe, Japan, as "America's Youngest Ambassador." At this conference, she recommended that the American and Soviet leaders have a granddaughters exchange program for two weeks each year, stating that a president would not want

to bomb a country his granddaughter was visiting. She made many media appearances in 1984. In 1985, she costarred with Robert Wagner in *Lime Street*, a popular television series.

Samantha's Legacy

On Sunday night, August 26, 1985, thirteen-year-old Samantha Smith, together with her father, Arthur Smith, four other passengers and two crew members of a Bar Harbor Airlines were killed in a plane crash while trying to land at the Auburn-Lewiston Municipal Airport. Samantha was able to accomplish more in her short lifetime as a peace ambassador than most professional diplomats achieve in a lengthy career. More than three decades since her tragic death, she is remembered for establishing bonds of friendship between adversaries at a critical period of the Cold War. Her memory lives on both here and in Russia.

THE HERMIT OF NORTH POND

PERCEPTIONS

We generally think of a hermit as a person who has chosen to live a life in solitude and prayer, often as a member of a church's religious order. We do have a group of nuns here in Maine who follow a long religious tradition at their Transfiguration Hermitage in Windsor.

There are others who have been emotionally sickened by the nonstop, 24/7 speed of the present world and the craziness of their jobs and have chosen to live a self-imposed life of tranquility in a remote cabin off the grid.

Christopher Thomas Knight, the hermit of North Pond, does not fit into either of these more traditional perceptions of today's hermit.

CHRISTOPHER THOMAS KNIGHT

Christopher was born on December 7, 1965. He grew up in Albion, a small town in northern Kennebec County. His father worked at a creamery, and his mother was a stay-at-home mom, taking care of him, his four older brothers and younger sister. Chris's young life seemed to be typical of kids growing up in rural Maine in that era. He enjoyed going on hunting trips with his father, sleeping on those trips in the back of their pickup.

Chris did exceptionally well with his studies and graduated early from high school. He was quiet, kept to himself and made no friends. After high school, he attended Sylvania Technical School in Waltham, Massachusetts, where he studied electronics. Upon completing a nine-month course, Chris took a job installing security systems in Massachusetts. He kept the job for about a year, bought a car and returned to his hometown.

The family lived in a two-story Colonial home on a fifty-acre wooded lot. They were an extremely private family. A neighbor of the Knights said that over the many years they had lived there, no one in the family had ever spoken a word to her. The family's extreme lack of any outward emotions may explain why they didn't report that Chris had vanished.

Life as a Hermit

Without saying goodbye to his family, Christopher Thomas Knight, at age twenty, took off on a journey as a hermit that would last for more than a quarter century. He didn't leave a job behind. He just wanted to get away from everybody and everything.

Chris set up his camp hideout in a deeply wooded spot, where a group of boulders together with hemlocks provided him with the perfect cover. There were numerous camps around the pond, but his spot was not visible. He could lie in his camp and hear hikers go by on the trail and folks paddling on the pond. When he set out, he brought very little in the way of supplies. This factor set him on a new survival occupation of breaking into camps around the pond for the sole purpose of obtaining food, batteries, beer, propane, tarps and other vital items. Chris never took anything of high material value for the purpose of selling it for money. He always conducted his robberies on the camps at 1:00 or 2:00 a.m., after he had checked to see that no one was present. He often borrowed a canoe to bring loot from across the pond back to his campsite. When he returned the canoe, he would always throw some pine needles over it to disguise that it had been used. His job back in Waltham installing alarm systems certainly came in handy when checking out a camp to rob. When fall came, it was time for the camp owners to batten down their sites for the winter and return to their year-round homes. This was the prime time for Chris to get a haul of goods to last him through the winter.

Chris took great care in camouflaging his site. He spray-painted trash cans forest green and used layers of brown tarp to cover his tent. His

careful security measures worked, as he could hear folks walking by on the trail and others paddling by on the pond, yet no one detected his presence.

Chris maintained a hygienic appearance. He took sponge baths, shaved, cut his hair and washed his clothes. His loot from camps included soap, shampoo, razor blades, toilet paper and even clothes pins. His menu was not always the healthiest, as much of the food he found in his burglary sessions was junk food, but it was sufficient to keep him alive. If he found a steak in a camp's freezer, he would see if they had a microwave oven so that he could thaw it quickly.

Maine winters can be hard, with temperatures falling to zero and below. Chris never lit a fire for fear the smoke would be seen, but he did light up a small propane stove to keep warm. Due to the limited amount of propane he had, he needed to watch his use closely, as he might not be able to steal anymore.

During his stay in the woods, Chris encountered only one person on a trail, and their verbal contact was a simple "hi."

Chris kept himself entertained at his site, reading hundreds of books he had stolen and by watching the changing of the seasons from his bunker.

THE FINALE

On April 4, 2013, the jig was up for Christopher Thomas Knight. While in the process of burglarizing the Pine Tree Camp in Rome, Maine, game warden Sergeant Terry Hughes captured Chris and charged him with burglary. He was then taken to the county jail in Augusta to wait trial. He finally had his day in court and was sentenced to seven months in jail. But since he had already spent nearly all of that time waiting for his trial date, Chris had only one week of jail time to do. In addition to the jail sentence, Chris was responsible to pay $2,000 of restitution to the victims of his burglaries. He was also ordered to complete a court program for people with substance abuse and mental health disorders. Upon completion of this program, he was placed on three years of probation.

Everyone in the judicial system found Chris to be an extremely ethical person. He confessed to having stolen from about forty camps per year, which amounted to about one thousand thefts. Judge Nancy Mills stated that she thought it was highly unlikely that Chris would be a repeat offender.

After completing all of his court requirements, Chris stepped back into freedom and took a job with his brother.

The Legend

The *New York Times* and other national and international media organizations carried this amazing story of a man living hidden in the woods of Maine for twenty-seven years without any human contact and surviving the hardest of winter weather.

Some locals of the area thought that he probably stayed in an abandoned camp during the winter months, but game wardens were quick to confirm that Chris's story was totally true.

Former *New York Times* writer Michael Finkel's book *Stranger in the Woods* (Knopf, 2017) provides both a wonderful read and insight into the man—Christopher Thomas Knight—who became the Hermit of North Pond.

24

THE ARTIST WHO PLAYED
ROBIN HOOD

A Personal Introduction

For years, my late wife, Jane, and our family vacationed in Maine. My initiation to Maine was in the summer of 1939, when my dad took my mother and I for a three-week vacation to Deer Island on Moosehead Lake. That trip hooked me on Maine, and we knew that someday I would live here. I introduced Jane to Maine in 1953, on a Fourth of July weekend trip to Sebago Lake. Maine was our vacation spot from then onward. Through the years, we spent summer vacations on Peaks Island in Casco Bay and in Maine's Western Lakes and Mountain Region. In the mid-1970s, as an empty-nest couple, we started to zero in on the area we wanted to choose for not only vacations and weekend getaways but also for our future retirement. We chose the Boothbay Harbor Region, because it was within a three-hour drive from the Boston area and was a very friendly community with all types of fine restaurants, cultural activities and a vibrant art colony, as well as having a wonderful marine heritage.

In April 1979, we found an old cape in Boothbay that we made an offer on, and in early June, we signed papers on our home in Maine. At this same time, I was working for Digital Equipment Corporation and wearing two hats as both operations manager and technical publications manager of the company's Commercial Engineering Group. This group was in the process of moving from Maynard, Massachusetts, to a new facility

in Merrimac, New Hampshire. It was my task as operations manager to coordinate the move of each project team when they completed their respective project. This involved me traveling back and forth between the two plants almost daily.

Jane had left her administrative position with a large mental health group to pursue a new career as a fine artist. We were also building a new home in New Hampshire as the 1979 summer season began. Jane decided to summer in our new Boothbay home and start to join the local art community, while I lived with my daughter Susan and my grandchildren during the building of our new home.

Independence Day 1979 fell on a Wednesday, so I decided that I would take the week off and start my vacation as of Friday, June 30. The challenge was to get to Boothbay from Maynard, as the country was in the midst of an energy crisis. Gas was being rationed at stations, and one had to wait in long lines at the pump. Luckily, I got enough gas to make it to Boothbay.

Jane filled me in on her week and on all the very interesting artists she had met. She told me about an artist who was also new to the area who she thought I would enjoy meeting.

Start of Friendship

After breakfast on Saturday morning, Jane and I went down town to Boothbay Harbor. After shopping at Grover's hardware store, Jane suggested we leave the car and walk down to Commercial Street to Pinchpenny Gallery. Here, Jane's new friend, Norman Andrews, was working as a pastel portrait artist on the gallery's deck. She told me that he had some of his watercolor works exhibited in the gallery.

Jane introduced me to Norm. He was a big bear of a man, about six feet, three inches tall and about 280 pounds, with a long beard. He was very outgoing, honest and friendly. He told us that he had come to Boothbay Harbor from Connecticut and that it was his first venture into Maine. He had worked doing portraits at a large department store during the Christmas season but hadn't had any real work since then. He hoped that his new Boothbay Harbor setup would be worthwhile. He also told us about his friend named Larry Willard, a staff writer for *Yankee* magazine who maintained a writing studio and who let Norm stay in it all winter. We concluded our visit by inviting Norm for a drink and dinner. Little did we know then that Norm would become more than a friend but part of our extended family.

Norm Andrews

Norm was born in October 1924 in Dayton, Ohio. His father was a local jazz musician as well as the operator of a music store. His mother was a stay-at-home mom. When Norm was around four or five, his parents divorced, and his mother took Norm to live in Manhattan with an elderly aunt.

While most young boys growing up in Norm's era followed baseball, Norm's interest was in films. He would go to the movies as often as he could. Instead of knowing the rosters of major-league teams and the batting averages of star players, Norm became a walking encyclopedia on who was in what films. He could tell you the scriptwriter, director and bit-part players.

Norm was a good student who enjoyed drawing and exploring nature and points of interest in the city. Upon graduation from high school, he was accepted into Columbia University (class of 1945). He entered his freshman year in the fall of 1941. Everything changed with the Pearl Harbor attack, and at the end of his first year in college, Norm volunteered for the U.S. Army Air Corps. He hoped to become a bomber pilot, but he flunked out

of flight school and was trained to be a glider pilot. Norm ended up flying troops in behind the lines on D-Day as a glider pilot. He was one of the few who survived that mission.

Upon completing his military service at the war's end, he returned to New York and enrolled in art school under the GI Bill. He followed this training with courses at the New York Art Student League. During this period, Norm lived in Greenwich Village. When his father died, he left Norm a small trust inheritance that yielded a small monthly income of around $100. Norm told me that helped pay for food and beer back in the late 1940s and early '50s. Norm secured a job as an illustrator with the *New York Daily News* and did some freelance work around the city for several years. Norm was a free spirt and one who lived in the moment. So, after a Christmas of doing portraits at Woolworth's in Times Square, he had his fill of the Big Apple and grabbed a Greyhound bus for Los Angeles.

On the Road

The next several decades saw Norman cross back and forth across the United States and Canada, working fairs, stampedes and college campuses as well as setting up in different towns and cities for short stays. In some communities, he would connect with a gallery, and his stay might be as long as six months.

When Norm had money, old VW Campers were his mode of transportation. He told us that cemeteries were safe places to camp for a night. If he found himself broke, he would thumb. He would go to a fast-food restaurant and scoop up a bunch of ketchup, buy a loaf of cheap white bread and make sandwiches. He said that sleeping behind large billboards was a good bet. Once in late November, he was driving west on the Trans-Canada Highway and stopped at a small mom-and-pop store and found that they were having a sale on roast beef, so he bought a roast and some aluminum foil. He had salt and pepper shakers, so he applied both on his roast, wrapped the roast in aluminum foil and placed it on the manifold to cook. I asked Norm, "How many miles per pound?" He never gave me an answer.

He had several lengthy stays by Norm's standards in the LA area. To supplement slim art pickings, he took bit parts in movies. He had a part in the film *Elmer Gantry*. His role was to jump in the water off of the Santa

Monica Pier, where the evangelist chapel went on fire. Norm's only problem with the role was that he didn't know how to swim. But he needed the money, so he got drunk, went into the water and survived for another day. Another hilarious adventure he told us was the time he took a job working for a mover in Hollywood. The crew he was assigned to was responsible for moving a baby grand piano up three flights of stairs to a music studio. Norm and his associates started up on their journey, but when they got to the second landing, they lost control of the piano. Down it went, crashing in the entry hall. Needless to say, Norm's moving career ended abruptly.

Norm did do a number of portraits of Hollywood artists and budding stars. Over a number of years, he had developed a friendship with Katharine Hepburn and her brother and had done a number of portraits of her both at her Hollywood home and at her home in Old Saybrook, Connecticut. One Christmas, Norm went down to Mexico and bought her a woolen poncho as a gift. He would later have her wear it in a portrait he did of her.

Norm's Boothbay Years

The summer of 1979 marked a turning point for Norm. He found the Boothbay region a place where he might be able to settle down, but changing a lifetime of wandering doesn't happen overnight. That summer, Norm did his portrait work on the deck of Pinchpenny Gallery and stayed in a tent at a local campground. When the season ended on Columbus Day, Norm had no plan for work until the Friday following Thanksgiving, when he would start his Christmas gig doing portraits at a department store in Hartford. That's when we became very close with Norm. We suggested that he could stay in the newly built studio/gallery of Jane's for his interim period between jobs. He jumped at the chance and became our star boarder. Jane's studio/gallery was physically just being finished, and she planned to open it for customers in 1980. That fall, Jane and Norm did a lot of painting together on location, and he provided some ideas for her gallery. Norm was a dog lover, and our three Kerry Blue Terriers—Katie, Michael and Molly—became close with him. He joined us for our Thanksgiving dinner, but as soon as we finished, he said his goodbye and took off in his old VW bus for Connecticut. After his Christmas season work ended, he hibernated, as in prior years, at Larry Willard's writing pad.

Like the hummingbirds' spring migration back to Maine, Norm showed up on our doorstep in late May 1980. He was extremely helpful in launching Jane's gallery. He suggested that since she was a "person from away" (PFA, in Maine lingo), it would be wise to have a marine-type name for her gallery, rather than use her name. She found the name she wanted at Maine's State Aquarium, on McKown Point in Boothbay Harbor. Exhibited in one of their tanks was a blue lobster, and posted by the exhibit was the statement that blue lobsters were one in a million. Thus her gallery's name: the Blue Lobster Gallery, one in a million. Norm also suggested that she ask some local artists to exhibit in her gallery. Carlton and Joan Plumber and Ruth Potter were among those who accepted Jane's invitation. Norm worked part time that season out of her gallery and at a downtown site the rest of the time. He also hung out with us a lot and plied his portrait skills, doing wonderful renditions of our whole family as well as of our three Kerries. When Boothbay's summer season officially ended on Columbus Day, Norm folded up his tent at the campground and moved into Jane's gallery for an interim stay.

May 1981 brought Norm back to Boothbay, and that season, he found a different spot to set up for his portrait work. One mid-July day, Norm played hooky from his post and went off to do some landscape painting. Around 5:00 p.m. (cocktail time), Norm showed up with a new, still-wet watercolor clipped to a board. He placed it down on our living room floor next to the entrance to our sunroom. We sat around talking and having a drink while Michael investigated Norm's new work. The next thing we saw was Michael lifting up his leg and peeing on the art. Naturally, the artwork was changed, but that's not the end of the story. Norm matted the piece and sold it the next day for $300. In classic Norman style, he announced, "I'm taking you all out for a feast at Lobsterman's Wharf." I told him that he should have given Michael credit for his enhancement to the painting. We had a great meal, and Norn thanked the waitress for her service and rewarded her with a $50 tip. Norm was broke again, but for one who lives in the moment, he was a millionaire, as he made people happy.

As Norm moved into the winter of his life, he found the Boothbay region to be comfortable and his wanderlust days as an itinerant artist coming to an end. He took a room in a home on West Street in Boothbay Harbor and settled into the community. The department store in Hartford had gone through a management change and was no longer interested in having Norman be part of their traditional season offerings. I suggested that he try offering his portrait work to military posts. He followed up on

this and worked at several naval facilities during the Christmas season and winter months.

During the late summer of 1986, our artist friend Ruth told us that she was taking an extended trip to Europe and asked if we knew of any reliable dog-loving person who could housesit and take care of Tyler, her Standard Poodle. We told her that we thought Norman would be a perfect person for the job. She had met Norm but didn't know him well, so we arranged for them to get together. The two hit it off immediately, and Norm took care of Tyler and Ruth's home while she was away. This led to a close friendship between the two.

Ruth was a wealthy widow with no children or living siblings. Her closest relative was a first cousin, Pam, who lived in Connecticut. After developing her close friendship with Norm, and knowing that he was penniless, as well as elderly, like herself, she asked her attorney to make Norman the sole beneficiary of her estate. Ruth's trust was to provide Norm with annual dividends for his lifetime and then transfer to her cousin, Pam.

Starting in the late 1980s, Norman rented a small efficiency apartment in East Boothbay and lived there year-round. When Ruth became ill with leukemia, Norm chauffeured her to doctors and helped with chores she needed done. He had no idea he was to receive an inheritance upon her passing.

He was completely shocked when Ruth's lawyer read her will and he found out that he had come into the largest amount of money he had ever known or even dreamed about. This change of economic status didn't change a bit of his lifestyle, except that he now had money to open a checking account and ask for credit cards.

Norm's personal mission of philanthropy was now put into action. As he received checks from credit card companies, he would execute them and take the cash and give it to the first case he heard of that was having a hard time. He would personally drive to find a family who had been burnt out of their home and hand them several thousand dollars. He knew his health was failing; the more he could help people at the expense of large banks, the better. Norm and all those he had the chance to help were the winners and the banks obviously the losers.

January 30, 2004, arrived. By 6:00 p.m., Jane said she was worried that something was wrong with Norm, as he had not called to wish me a happy birthday. About 8:00 p.m., she asked me to call St. Andrews Hospital to see if he had been admitted. I called the hospital, and they told me they had no patient by the name of Norman Andrews. I received the same answer from

the Damariscotta Hospital. We knew that Norm would not be out this late on a cold winter night, so I called the Lincoln County Sherriff's Office and asked if they could check on him. About 10:30 p.m., they called me back to tell me that they had found Norman dead in his bed.

Norm's Legacy

Norm's lawyer called to tell us that he had requested that there be no funeral service and that he be cremated and that Jane and I should appropriately care for his ashes. We met shortly after that with the lawyer. In addition to providing us with Norm's ashes, he laughed, telling us how Norm "beat the system" helping so many people and playing the part of Robin Hood. The lawyer was sure that Norman died a rich man in the eyes of God.

Ruth's inheritance transferred directly to her cousin Pam upon Norm's passing. Pam also received from Norm a portfolio containing dozens of charcoal sketches and pastel portraits of his idol and friend, Katharine Hepburn. It was Norm's wish that a proper venue be found to showcase and honor her film career. Pam was given the task of handling his wish. Pam was a Connecticut state legislator at the time, so the *Hartford Courant* picked up the information and ran the story by the paper's staff writer, Claudia Van Hes, with the caption "Maine Artist's Legacy: Portraits of Katharine Hepburn."

The paper's staff writer only saw a small part of Norm's legacy. She didn't know about all the people he had helped in so many different ways and places over his lifetime. That was his true legacy.

A TOWN LOOKING FOR A FESTIVAL

THE HOME TOWN

Dexter is a small rural town in northwestern Penobscot County. It was incorporated in 1816. Its many waterways—including the Kenduskeag River, Sebasticook, Main Stream and Dexter and Spooner Ponds—made the area a center for manufacturing starting in 1835 with the opening of a woolen mill. Manufacturing operations were attracted to the community. It became known for its woolen clothing, boots and shoes, metal goods and much more.

Starting in the 1960s, the town's manufacturing base started to slowly erode. Over the next four decades, the town lost all of its once-dynamic posture and saw its population shrink each year. The gem had certainly lost its luster, and a melancholy appearance was prevalent.

SEARCHING FOR A SOLUTION

The town fathers needed something that would bring the townspeople together and bring folks into the community to start a revitalization of their town. A festival of some kind could be the answer, but what kind of a festival could they come up with as a Johnny-come-lately to the festival arena?

Maine is big on festivals, and towns across the state have their festivals swing into action each year. Some communities have had these annual events for decades. Looking around, they found that Cape Lizabeth had its strawberry festival and Machias had its wild blueberry festival. Yarmouth had its clam festival, Rockland its lobster festival and Eastport its salmon festival. Finding a unique idea for a festival was difficult. They kept looking, and the more they looked, the tougher it seemed to get. They found Boothbay Harbor had its windjammer festival, Fort Fairfield its potato blossom festival and Millinocket it trails end festival. They found Lisbon Falls had been celebrating with Moxie, while Dover-Foxcroft had chosen the whoopee pie for it festival. After a great deal of deliberation, they found a unique Maine treat to celebrate that no community had yet latched onto: the Red Hot Dog.

A MAINE ICON

Two Maine families have been manufacturing meat products here for more than 150 years. W.A. Bean & Son and Moses C. Rice were major competitors in the pork products business. For years, Moses Rice had the exclusive market on making the red-skinned hot dog that folks in Maine loved. It was also a favorite with vacationers who wanted to have a taste of their delicacy. A deal was struck between the two competitors, and today, W.A. Bean & Son is the proud producer of this iconic sausage.

DEXTER HAS ITS FESTIVAL

The summer of 2015 saw the first Red Hot Dog Festival celebration in Dexter. It more than met its goal and is now an annual part of Dexter's events. The festival is held each August and has brought thousands to the community to enjoy a unique treat and lots of fun. All money raised goes to the town's revitalization committee.

26.

THE "KNOW NOTHINGS"
IN ELLSWORTH

A little less than one hundred years after the settlement of Union River (Ellsworth's original name) in 1763 by a party of English entrepreneurs led by Benjamin Milliken and Benjamin Joy, the community saw a large influx of Irish as a result of the potato famine in Ireland that forced them to immigrate. Many came over on the open wooden boats that carried Canadian lumber to England and Ireland and provided cheap return transit. A large number of the Irish who arrived in St. John, New Brunswick, wanted to go on to Boston, where they had relatives who would help them find work. Ellsworth became an important stopover for many of these Irish immigrants in the mid-nineteenth century. Some decided to stay and find a new life in Ellsworth. Their culture and religion were entirely different from the local Yankees and a potential point of friction between the two groups. It is within this historical framework that Father John Bapst, a Swiss-born Jesuit, took up residence in Ellsworth in January 1853.

Father Johannes Bapst arrived in New York in July 1848 with a group of forty-four Swiss Jesuits who had been exiled from their homeland by a civil war. On August 7, 1848, Father Bapst took up his first assignment in Maine on the reservation of the Penobscot Nation on Indian Island. He and Father James Moore, SJ, were charged with restoring the Jesuit mission in Maine. Father Bapst remained at Indian Island until September 2, 1851, when he moved to make his headquarters in Eastport. The Jesuit's Maine mission was to serve the spiritual needs of the growing Catholic population scattered throughout Maine and in danger of losing their faith due to a

lack of priestly care and parish life. At that time, the Jesuit mission circuit consisted of thirty-three stations. The sheer magnitude of the task and the geographic area that needed to be covered allowed for each mission station to be visited for only a few days six times each year. From Eastport there were stations on Louis Island, Calais, Robinston, Pembroke, Pleasant Point, Lubec, Trescott and Machias. Along or near the Penobscot River were stations at Cherryfield, Benedicta, Old Town, Frankfort, Bucksport, Belfast, Rockland, Thomaston and Ellsworth. On the Kennebec were Waterville and Skowhegan. Covering the towns and stations near Eastport was more than three priests could do, which made Bishop Fitzpatrick suggest developing another center nearer to the Penobscot. Ellsworth was considered to be the best location for this new center.

Catholics in the Ellsworth area had acquired a small building that was used as a chapel in the 1840s and early 1850s. As a mission station, it is most probable that the Reverend Thomas O'Sullivan from the old St. Michael's Church in Bangor was the first priest to hold services in Ellsworth on an occasional basis. Father Bapst made the construction of a new church a top priority for initiating the new central mission center. The new church was completed near the end of 1853.

During that period, it was the practice for parents to bring the books their children would use. Since everyone had a Bible, it had long been the custom to use it as a common reading book. The newly arrived Father Bapst became involved in an Ellsworth School Committee order that all students must read from the Protestant King James version of the Bible or be expelled from school. Father Bapst objected to this and requested in a petition to the Ellsworth School Committee that Catholic students be free to read from the Catholic Douay version of the Bible. The dispute could have been easily resolved if they followed the Bangor school officials' policy of allowing students to make their own personal choices in the matter. Since the school committee stuck to its order, Father Bapst, with the support of his parishioners, filed a suit against the town. This resulted in the fiery editor of the *Ellsworth Herald*, William H. Chaney, repeatedly attacking Father Bapst in his paper and warning readers that their Irish servants would poison their food in order to wipe out Protestantism in the area. On June 3, 1854, a mob gathered at the rectory. When told that Father Bapst was not in, they broke some windows. A few days later, the mob returned to attack the church. Thanks to the intervention by Colonel Charles Jarvis, only minor damage occurred. Fearing for Bapst's life, Bishop Fitzpatrick had him transferred to Bangor. The transfer did not suppress the anti-Catholic and anti-immigrant

wave known as the "Know Nothings" movement that was spreading in Ellsworth as well as across the country. Chaney, a vocal champion for the Know Nothings, kept the controversy raging. On October 14, 1854, Father Bapst went to stay the night at the home of the Richard Kent family in Ellsworth on his way to attend a sick call in Cherryfield. That evening, a local Ellsworth version of the Know Nothings called the Cast Iron Band found out that he was back in town. Members of the band dragged him from the house, beat him, took his wallet and watch, stripped him, tarred and feathered him, tied him to a rough plank and carried him out to the woods, where they left him. Thankfully, Bapst was found by friends, who took him in and cleaned him and helped him get back to Bangor.

At the height of the Know Nothing movement, Bapst helped organize the building of St. John's Catholic Church on York Street in 1856. St. John's stands as a tribute to the Queen City's Irish American immigrants. This landmark is listed in the National Register of Historic Places.

Father Bapst was transferred in 1858 to Boston, where he helped raise funds for the construction of Boston College on Harrison Avenue in the South End. Father Bapst and fellow members of Boston's Jesuit community saw the need for an institution that would provide a rigorous academic curriculum to the sons of the growing Irish immigrants in Boston. August 1863 saw the election of Father Bapst as the college's first president. From its humble beginning a little over a century and a half ago, Boston College now resides on a 332.5-acre campus in Chestnut Hill, Massachusetts, about six miles west from its start on Harrison Avenue in Boston. Today, the college is coed and has 9,100 undergraduates from across America and the world, as well as a large number of students enrolled in postgraduate programs. In *Forbes* magazine's 2016 edition of America's Top Colleges, Boston College was ranked twenty-second in the nation.

VISITS FROM UNCLE CHARLEY

Our First Encounter

In late July 1996, Jane and I took a weekend camping trip way Down East to Cobscook Bay State Park in Dennysville. This was our favorite campground, and we tried to make at least two trips there a year. We settled in at a nice site on the water that Friday afternoon. Soon after setting up camp, a storm rolled in and set the stage for a washout weekend.

Waking up on Saturday morning to a rainy day, we decide to explore a piece of Washington County—we didn't want to just stay inside of our seven-and-a-half-foot truck camper, watching it rain. After breakfast, we took off for a day of exploration. About 11:00 a.m., we found ourselves on Route 1 in East Machias, where we saw a sign for Bucks Harbor. The name intrigued us, so we turned and followed the signs to this exciting-sounding destination. After weaving our way down this trail less traveled, we arrived in Bucks Harbor. There, Jane spotted an old abandoned cape home and barn with grass in the front yard a foot high, but for some reason, Jane was drawn to this place. She said, "Let's check it out after we finish exploring the harbor." After our harbor adventure, we stopped in the driveway in front of the barn to look the abandoned place over. The barn had a traditional large barn door, but on the far left side of the ban we noticed a deck leading toward the back. We followed the deck, which took us to a beautiful wide deck extending the length of the barn.

When we reached its center, we saw that it had a glass slider, allowing us to view inside. To our astonishment, the interior walls were completely finished off, with what appeared to be white painted sheetrock. The floor of the barn was made from wide pine, while directly at the barn's front door was a slider that had been hidden from us by the large exterior barn door that had been pulled closed over it. Jane exclaimed, "What a fabulous gallery this would make." Next, we crossed over to take a look at the house. It too had a beautiful large deck running the length of the back of the house. The deck provided us with a panoramic view of the harbor. A slider gave us a look into a large living room. It also had white interior walls. At the other end of the barn was a standard-size door with glass that provided us with visibility into the kitchen. I told Jane, "No one in Maine locks their cellar. I'll go down through the bulkhead and see what is down there." When I entered the cellar, I saw a light switch. I tried it, and on came the lights.

The cellar also was a big surprise, as the house's electrical, plumbing and heating systems were all relatively new and had been done by professional tradesmen. When I came up from the cellar, I told Jane of my find. We were not house hunting, but this property had certainly gotten our attention. Jane spotted a small sign of the real estate firm handling the property tacked to the front door. She copied down the phone number and asked me to give them a call and see what they were asking for the property. On Monday morning, I called Eastland Realty in Machias and talked with the owner, Bill Parker. He told me that the property was owned by a woman friend who had run a very successful real estate appraisal business but had developed cancer. Unfortunately, she had limited health insurance and owed huge hospital bills to Dana Farber in Boston. The bank that held the mortgage on the property was going to foreclose within two weeks. The result of this situation was that the property was on sale at a fixed fire-sale price. I couldn't believe the price and said that we would like to come back up that Friday and see the inside of the house. Obviously, we went up and signed a sales contract. We could not believe we had bought a new home when we had no intention of selling our Boothbay house

We passed papers on the house in September but did not actually move to Bucks Harbor until the ice storm of January 1998, when our granddaughter Jennifer and her husband, Adam Maguire, acquired our Boothbay home.

During dinner, shortly after having moved in, we thought that we saw an older man in dark attire cross the back deck. Jane left the table

and looked on the deck and saw nothing. I went and looked out in the driveway, and there was no car to be seen. We chalked it up as a strange event, nothing more.

New Events Happen

In the spring of 2006, Jane's breast cancer reoccurred for the fourth time after being in remission for nearly a decade. We were naturally very upset but had a positive attitude because Jane was a tough fighter and had beaten it before. We connected back with Dr. Dixie Mills, a breast cancer specialist and surgeon, and Dr. Thomas Keating, an oncologist. These two were the team Jane had worked with in prior bouts. They were both associated with Maine Medical in Portland and Brunswick, respectively.

After Dr. Mill's surgery, Jane met with Dr. Keating, who recommended that radiation was the appropriate procedure for her. He would consult with an oncologist radiologist, who would get back to her with a scheduled start date.

Upon our return home, Jane said that, as much as she would hate to leave Bucks Harbor, she thought it would be more practical for us to move back to the mid-coast, as it is a four-and-a-half-hour drive down to Portland. I agreed, and the next day, we placed our home on the market.

The real estate agent took a number of pictures of our property and questioned us in detail about its history. We told her we knew that Charles Johnson had the house and barn built for him in the 1890s and that his two brothers-in-law had the same builder erect homes for them on either side of him. This builder also constructed three homes directly across the road during the same period. We also told her that Gwen Hooper Wood, who grew up as a child across the street from the Johnson home, used to go into the barn and feed Mr. Johnson's cow and horse. She told us that he was a very kind man and that all the kids in the neighborhood called him Uncle Charley. He owned a small store just up the road, and when a kid stopped to pick up something for their mother, he always gave them some penny candy. We noted to the agent that when the previous owner updated the property, she was meticulous in maintaining the architectural integrity of the 1890s.

When Jane heard from the oncologist radiologist, he said he saw that we lived way Down East and thought it would be much easier for her to receive her treatment in Bangor and that he could refer her to an excellent doctor.

Jane agreed with his recommendation and was scheduled for her radiation. We found a motel in Brewer that offered a special discount to Eastern Maine Medical patients, which we took advantage of. The motel provided us with a small efficiency apartment and was dog friendly, as we wanted to be able to keep Annie with us. This arrangement turned out to be an excellent option and an economic choice, as gas was very expensive. During the six and a half weeks of the program, we would go home every Friday after Jane's procedure and return to Brewer on Sunday afternoon. Thankfully, Jane didn't have any real side effects from the radiation, which allowed us to explore Bangor during a beautiful fall season.

About the fourth week into her program, Jane had a 9:00 a.m. Friday session. She was all free by 10:00 a.m., so we headed home. Just after having lunch, we received a call from the real estate agent that she had a potential buyer, who wanted to have a showing of our home. We said, "Great, and we will clear out." Jane, Annie and I took off for an afternoon drive to allow the agent to have plenty of time to show our home. We returned around 4:00 p.m., and Jane prepared dinner. We sat down to dinner around 6:00 p.m., and about halfway through our meal, we heard a crash from the kitchen. Jane jumped up and went to the kitchen but found nothing wrong. She then went into the adjoining pantry, where she could not believe her eyes about what had happened. She called for me to come and see that a large pot on the top shelf had fallen on to the next shelf and hit a small pot in the process, which caused the noise. What was unusual was that the pot had to do a 180-degree turn to accomplish this feat, which seemed impossible. But we observed that it had happened.

On Saturday, the U.S. Mail brought us an unexpected turn of events, in a letter from Dr. Dixie Mills informing us that she was leaving her Maine practice to join the famous breast specialist Dr. Susan Love at UCLA Medical Center to work on a research project to find a cure for cancer.

A FEW DAYS AFTER Jane completed her radiation and we returned home, our real estate agent called to tell us two prospective buyers would like a showing of our property about 2:00 p.m. We said, "Great, we will go out and give you plenty of time to show our house." We returned at dusk, fed Annie and then relaxed with a cocktail in the living room. We had hardly had a sip of our drink when a strange crash occurred behind us. A small clock on our stereo system flew off onto the middle of the living room rug.

If we hadn't heard and seen what happened, we would not have believed it. Can strange messages happen twice? They did.

A third showing was held the following week. This prospective buyer was interested but was a very demanding individual whom I took an immediate dislike to. I did cooperate with our agent in providing for all of his requests. After completing a call with our agent, we went into the living room to relax. As we entered the room, we saw the little clock take a flying leap off the stereo again. We both said in harmony, "We are being given a very strong message. We are supposed to stay in Bucks Harbor." I called our agent and told her to take our home off the market, we are not selling.

A PARANORMAL EXPLANATION

A short time later, Jane was shopping at Hannaford in Machias and ran into Rhonda Graven. Rhonda and her husband, David, are neighbors. They have a farm and raise a large flock of sheep as well as other animals and crops. Jane told Rhonda our story and that we were staying. Rhonda then told Jane that she could solve a part of our strange tale. She was the great-niece of Uncle Charley, and she had seen his apparition walking in their pasture and thought for a moment, "Uncle Charley's out there." Then she realized that he had died many years before and she was seeing his ghost. She said, "Uncle Charley obviously likes you and was telling you to stay in his house."

A FINAL CHAPTER

In May 2015, Jane and I re-discussed our funeral plans. Our plans had called for our burial to be in the Harnedy family lot at Holyhood Cemetery in Brookline, Massachusetts. We were now in our eighties, and for whoever was the survivor, having to drive seven and a half hours to the cemetery after the funeral service in Machias would be extremely stressful, so we decided that we should be buried where we had chosen to live out our lives. We went ahead and purchased a lot at Hillside Cemetery in Bucks Harbor. The day we picked out our lot, we walked around the

cemetery and found the stone marking Uncle Charley's resting place, so we stopped and said a prayer. When we arrived home, we found that the small clock had been moved 180 degrees on the stereo system as if to say "thank you" for stopping by.

On December 18, 2017, when the time had come to bury my life partner, I was pleased she would be still close by here in Bucks Harbor.

ACKNOWLEDGEMENTS

I first want to thank my daughter Susan J. Blackwell for all of her advice during the project and, in particular, her copyediting skills.

I wish to thank my friend and neighbor Harley Flynn for sharing the illuminating story of his dad's escapades rumrunning Down East on the *Grey Ghost* during the Prohibition era.

I also want to give thanks to my editors, Michael Kinsella and Rick Delaney, at The History Press, for all of their help throughout the project.

ABOUT THE AUTHOR

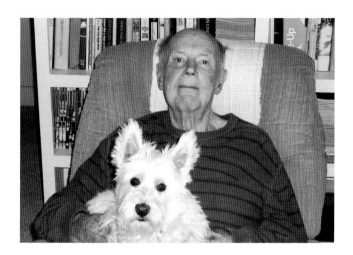

J im Harnedy is an octogenarian and a native of Brookline, Massachusetts. He has resided in his adopted state of Maine for four decades. He is a retired computer executive and, in his third career, has authored ten books as well as a number of articles for both local and national publications. He did his college preparatory work at St. Sebastian's School and received his bachelor's degree in history from Boston College. He did postgraduate work at Georgetown University and at Framingham State College.

Among his many interests have been organic gardening, raising and showing Kerry Blue Terriers, camping, reading and enjoying the changing seasons that New England provides.

Jim has been active in both his community and church. Since a health issue required him to downsize his medium-sized canine companions, he has acquired a wonderful little Scot, named Duncan, a West Highland White Terrier.

Jim is the father of two daughters and has four grandchildren and nine great-grandchildren.

Jim and Duncan live way Down East in Bucks Harbor, Machiasport, Maine.

OTHER BOOKS BY THE AUTHOR

The Boothbay Harbor Region. Images of America (Arcadia Publishing, 1995)

Around Wiscasset. Images of America (Arcadia Publishing, 1996)

Maine. The Best Images of America, Selections (Arcadia Publishing, 2000)

A Handy Guide for Eucharistic Ministers (Alba House, 2001), Jane Diggins Harnedy with Jim Harnedy

The Machias Bay Region. Images of America (Arcadia Publishing, 2001), with Jane Diggins Harnedy

Campobello Island. Images of Canada (jointly released by Arcadia Publishing and Vanwell Publishing Limited, 2003), with Jane Diggins Harnedy

The Boothbay Harbor Region. Scenes of America (Arcadia Publishing, 2006)

The Machias Bay Region. Scenes of America (Arcadia Publishing, 2006), with Jane Diggins Harnedy

Historic Churches, Synagogues and Spiritual Places in Eastern Maine (The History Press, 2011), with Jane Diggins Harnedy

A Brookline Boyhood in the 1930s & 40s (America Through Time, an Imprint of Fonthill Media, marketed and distributed by Arcadia Publishing, 2017)

Visit us at
www.historypress.com